The Art of
Lord Leighton

The Art of
Lord Leighton

Christopher Newall

Phaidon Press Ltd
2 Kensington Square
London w8 5ez

First published 1990; first paperback edition 1993
Reprinted 1994

© 1990 Phaidon Press Limited

ISBN 0 7148 2957 9

A CIP catalogue record for this book is available from the
British Library.

Printed in Italy

Photographic Credits

Half-title. *Artist sketching in the Cloister of San Gregorio, Venice*.
Oil on canvas, 13 × 9½ in. (33 × 24.2 cm.). Collection of Mr and Mrs
John Gere

Frontispiece. *The Syracusan Bride leading Wild Animals in Procession
to the Temple of Diana*. Exhibited 1866. Oil on canvas, 53 × 167 in.
(134.7 × 424.3 cm.). Private collection

Contents

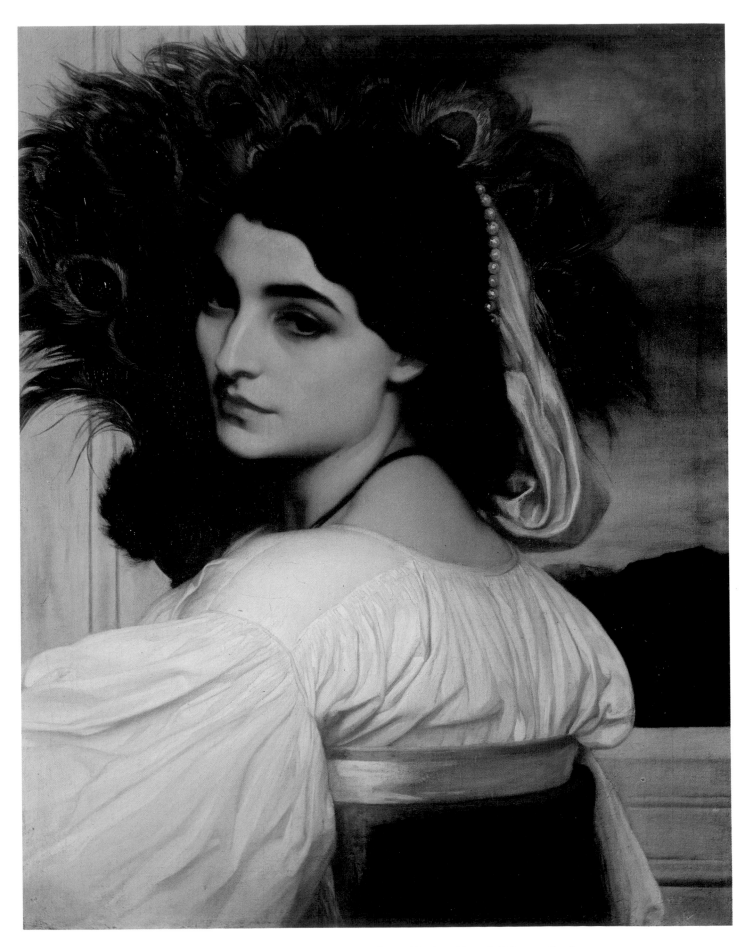

1. *Pavonia*. 1859. Oil on canvas, 21 × 16¹/₂ in. (53.3 × 42 cm.). Private collection

Preface

Many of those who have set themselves the task of writing about the careers and work of artists of the Victorian era have echoed the words of Lytton Strachey: 'The history of the Victorian Age will never be written: we know too much about it.' Frederic Leighton, the most eminent and widely admired artist in Victorian public life, is extraordinarily hard to pin down in terms of his inner sensibility as a painter, and this is despite the fact that we have vast funds of information about his life. Quantities of his letters as well as notes of his conversations and statements on art have survived, but these seldom elucidate the personality of the man. His Addresses to the students of the Royal Academy were the result of earnest deliberation, but their intellectual abstraction and overall tidiness of organization make them impersonal and tedious to read. We know which paintings by the Old Masters he liked to look at, which antique statues he particularly admired, and what books he had in his library; but whether he was moved emotionally by the experience of great art and literature is by no means clear. Nor can we be sure how he reacted to his contemporaries or what he expected from his friends, because seldom does a sense of any warmth of character transmit itself to us. In short, we know all too much about the events of Leighton's life – his movements, his contacts with his contemporaries, even his disappointments and achievements – but as a personality he remains elusive and contradictory. Leighton the man seldom provides the clue to the understanding of Leighton as an artist.

The events of Leighton's public life, his successes and failures as a professional artist as well as his conduct of the Presidency of the Royal Academy and his role as ambassador extraordinary of the Victorian art world, have been recorded by his early biographers John Edgcumbe Staley and Mrs Russell Barrington; furthermore, a rounded biographical portrait of Leighton, combined with an analysis of his stylistic development, is provided in the only modern monograph which has been devoted to him, that of Leonée and Richard Ormond published in 1975. Partly because Leighton's biographical details are available in existing books I have elected to restrict information about his life to a bare minimum, just enough in fact to provide a structure of chapters based on the steps he made in the progression from obscurity to professional pre-eminence.

Instead, I have chosen to concentrate on the works themselves; to give an account of the narratives they record or the moods they represent; to analyse their constructions and compositions; and to give an idea of what kind of reception they had when first exhibited. I have discussed them in approximately the order they were produced, and this inevitably leads to a somewhat erratic view of his artistic development, for his career and style of painting did not always follow a smooth or consistent path. Although I have been careful to give a fairly even chronological spread of his work in the plates, I cannot claim that what is shown is more than a representation of his art. The choice of plates must inevitably reflect my own subjective predilections and tastes.

The difficulty with an approach which seeks to learn something about Leighton's mentality principally

through the medium of his works is that his art has built into it some of the same kind of defences which he hid behind in life; as John Christian once wrote: '[Leighton's art] like his life . . . presents the world a hard glossy carapace apparently designed to resist the critic's probe.' When talking or writing about Leighton's work one inevitably falls back upon a theoretical language of art; adjectives such as 'classical', 'aesthetic' and 'academic' tend to become over-used and are perhaps too loosely defined. The purpose of this book is to assess what Leighton's aims were when he painted (and sculpted), and to gauge how his works operate on the spectator.

Leighton's aesthetic standpoint was remote from the mundane practicalities of life, and his work must be considered in the light of the late nineteenth-century philosophy which held that beauty was an absolute goal of artistic activity. When looking at his works and thinking about the nature of his art, I have had cause to ask myself not only 'How do I react to the subject and composition?', but also 'Do I find the work abstractly beautiful?' Leighton cared passionately about his art, which he saw both as a means of addressing a wide public and as an exploration of the way in which the appearance of the external world could be recorded by the intuitive handling of paint. His works represent a variety of artistic purposes and solutions, and it is across the range of his productions that one must look for indications of the artist's warmth of sentiment.

Different views may be taken as to Leighton's stature and significance as an artist. On the one hand he has been seen as the heir of an artistic renaissance which occurred in Victorian England; on the other his conscious but remote emulation of classical prototypes has been written off as the final feeble florescence of European neo-classicism, lavish in its decorative function but bland in content. I must say at the outset that I am by no means certain that Leighton was always successful in what he tried to do, much less that he was necessarily a great artist, even despite his having created some of the nineteenth century's most compelling images. I hope that in my discussion of his works I will at least establish the criteria by which what he was trying to do may be judged, and on that basis perhaps an estimate of his significance may emerge.

In the course of writing this book I have benefited enormously from the enthusiasm and erudition which various friends have shared with me. Foremost among the circle of Leighton's modern-day admirers are Richard and Leonée Ormond; I am grateful to them for their encouragement and most helpful suggestions. Two other scholars of Victorian art whose insights have helped me form my own ideas about him are Hilary Morgan and Benedict Read; I am indebted to them both. Others who have shared their knowledge of Leighton with me and generally taken an interest in what I have been trying to do have been Joanna Banham, Julian Hartnoll, Robert Isaacson, Jeremy Maas, Simon Taylor, Andrew Wilton and Christopher Wood. I have looked closely at as many paintings, drawings and sculptures by Leighton as I have been able to, preferring not to rely upon photographs or my memory of works seen in the distant past; my sincere gratitude goes to all those collectors, museum curators, picture dealers and auctioneers who have allowed me the opportunity to study works by Leighton in their possession or care. I am also very grateful to those who helped me to gather together suitable illustrations for this book. Lastly I should like to thank Penelope Marcus at Phaidon Press for allowing me further to indulge my enthusiasm for the art of the Victorian era; Diana Davies for helping me to present the text in a comprehensible form; and my family, Jenny and Alfred Newall, for the forbearance they have shown in leaving me alone when I appeared to them to be just dreaming but was in fact, at least so I claimed, working.

1

The Outsider, 1855–1864

Leighton differed from the generality of English painters in the years after the middle of the nineteenth century in that he had spent very little of his boyhood and youth in England. It was not unusual for artists to train abroad for a year or two, but to have passed almost all of one's formative years in the course of a restless peregrination around Europe was exceptional. Born in Scarborough on 31 December 1830, the young Leighton made his first trip abroad, to Paris, in 1839. By this stage he was already showing signs of a compulsive interest in art and had become an enthusiastic sketcher. In 1841 his father, Dr Frederic Septimus Leighton, inherited a fortune from his father, who had been physician to the Czar of Russia; he decided to give up his own career as a doctor, preferring to travel in Europe for the sake of his wife's health and the education of his son and two daughters.

Because of his peripatetic upbringing Leighton was from an early age cosmopolitan in outlook and culturally voracious. By the age of fifteen he had decided to become an artist and in October 1846 he began his formal training, at the Städelsches Kunstinstitut in Frankfurt. Later he studied in the art school at Florence. If Leighton's artistic mentality was formed during his youthful sojourns in Germany, Belgium, France and Italy, so was his personality as a man.

None the less Leighton's ambitions as a painter—and these were intensely felt even as a boy—were only to be satisfied by his gaining the most prominent position in the arts in English public life, and his being acknowledged as England's principal painter. On his occasional visits to London he sounded out who his future competitors might be, and tried to assess the course painting in England was likely to take in the years to come. In 1849 he wrote approvingly: 'There is a new school in England, and a very promising one; correctly drawn historical genre seems to be the best definition of it. They tell me that there is a fine opening for an historical painter of merit, and that talent never fails to succeed in London.' His path to fame was to prove by no means as easy as he anticipated.

Leighton first exhibited a painting, *Cimabue finding Giotto in the Fields of Florence* (Baroda Museum and Picture Gallery), in Frankfurt in 1850, when still a student of Edward von Steinle. In stylistic terms it shows the influence of Peter Cornelius and the other German Nazarene painters who sought to give honest and unpretentious representations of figurative subjects in landscape settings. More consciously decorative was *A Boy saving a Baby from the Clutches of an Eagle*, of which the watercolour version (plate 2) seems to have been given by the artist to Steinle.

An early self-portrait of 1852 (plate 3) shows Leighton self-consciously identifying himself as a painter by the emblematic display of an artist's palette. The shirt sleeve, which he arranged to rest on a ledge in the forefront of the composition, is the first of many instances of a deliberate display of bravura drapery painting.

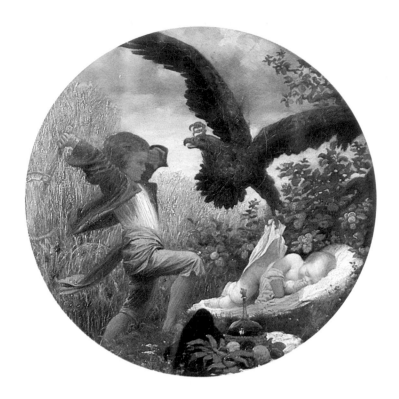

2. *A Boy saving a Baby from the Clutches of an Eagle. c.* 1850. Watercolour, diameter: 12¹/₄ in. (31 cm.). Private collection

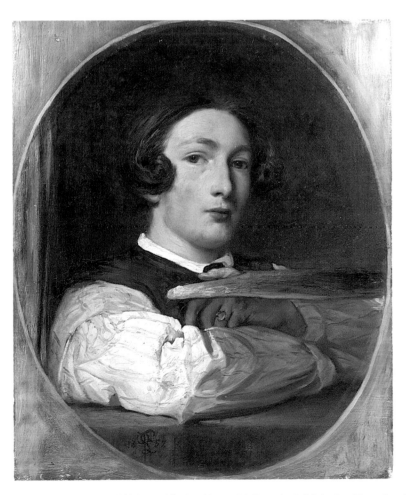

3. *Self-portrait.* 1852. Oil on canvas, 22¹/₂ × 18³/₈ in. (57 × 46.7 cm.). Städelsches Kunstinstitut, Frankfurt

4. *A Venetian Well-head*. 1852. Pencil drawing, 10 × 7⁵/₈ in. (25.4 × 19.3 cm.). Private collection

He had studied Rembrandt's work in Holland and in his early self-portraits he adopted the poses and play-acting of Rembrandt's own portraits of himself as a young man. In the same year that he offered this precocious view of himself, he travelled to Italy, and studied with avid enjoyment the paintings and architecture as well as the cityscapes and landscapes of that country. His minutely accurate drawing of *A Venetian Well-head* (plate 4) reflects his passionate inquiry into the exact forms and textural qualities of what he saw.

One of the first paintings in which Leighton showed his independent power of pictorial invention was the portrait, done in Rome, of Isabel Laing (plate 5). She was the daughter of friends of his family, and had just arrived in the city when it was arranged for Leighton to paint her. The work depends on the conventions of European society portraiture of the mid-century: even so, it incorporates elements which lend pictorial and psychological drama, notably the strong silhouette of the girl's head and profile and the tensely spread fingers of her right hand, resting on the parapet. This elaborately dressed and coiffed young woman, posed in front of a marble column with a view beyond into an ornamental garden, presides over her surroundings like a diva in mid-performance.

5. *Isabel Laing.* 1853. Oil on canvas, 41 × 29 in. (104.2 × 73.6 cm.). Fitzwilliam Museum, Cambridge

In Rome Leighton made drawn portraits of the new circle of friends that he made there, and which included both semi-bohemian figures and members of fashionable society. His drawing of Walter Creyke (plate 6) is direct and undemonstrative, and suggests the affectionate camaraderie of the life that he led.

Two major paintings derive from the period that Leighton spent in Italy in his early twenties. The first of these, *The Reconciliation of the Montagues and Capulets over the Dead Bodies of Romeo and Juliet* (plate 7), which Leighton worked on in Rome from late in 1853 and exhibited at the Exposition Universelle in Paris in 1855, was highly theatrical and in effect a tableau from the play as performed on stage. The setting, Italy in the Middle Ages, served the artist's early propensities for period and place. The *dramatis personae* are carefully arranged to provide two separate and conflicting patterns: at the extreme front lie the bodies of the lovers,

6. *Walter Creyke.* 1855. Black chalk on white paper, 9 × 7¼ in. (22.8 × 18.5 cm.). British Museum, London

Romeo with his arms thrown back in the abandon of death, Juliet clasping his head with hands and arms which still embrace with physical passion. Juliet's mother has thrown herself upon her daughter's body, and she herself is in effect lifeless as no sight of her face or hands is allowed. The draperies of Juliet's sheer white dress, and of her mother's mauve-pink robe and the yellow cloth which covers her head, form the central compositional motif, and seem to flow with a viscous quality across the foreground. On the right-hand side lies the body of Count Paris, and to the left, almost in the foreground plane, stands Friar Lawrence. These five figures make a dynamic zigzag shape across the painting: the way in which the dead bodies fuse and support each other conveys the tragic symbolism of the piece. Less successful is the scene of reconciliation in the centre. The three figures of Montague, Capulet and Prince Escalus form a tidy square which rests uneasily beyond the long diagonal of the foreground.

The artificiality of the lighting heightens the sense that one is witnessing a performance rather than a scene from life. The foreground figures seem to glow luminously, while the central group is seen in half-light,

and the remaining part recedes into shadowy obscurity; the blocked-out and compositionally unimportant background is exactly like that of a stage set. Leighton may have had Caravaggio in mind when he painted this picture—he certainly must have looked at the Italian painter's nocturnal subjects in Rome; but the obvious manipulation of the light source, as well as the too-carefully orchestrated range of gestures, have made the effect melodramatic. Leighton has offered a finale to a play, with all the protagonists present for the final curtain fall, rather than a scene of human tragedy.

The Reconciliation of the Montagues and Capulets was out of date before it was done. The taste for painted repetitions of familiar and romantic themes was dying out in favour of more psychologically complex subjects. Certainly no great excitement was caused by this early bid for fame on Leighton's part, notwithstanding its remarkable drapery passages. In fact for several years he was unable to sell the painting despite consigning it to the art dealer Colnaghi. In due course it was exhibited in Manchester, and then in New York, where it was eventually bought by an American collector.

Leighton was at work on a second history painting in his studio in the Via San Felice during the last months of 1853 and throughout 1854, to be entitled *Cimabue's Celebrated Madonna is carried in Procession through the Streets of Florence; in front of the Madonna, and crowned with Laurels, walks Cimabue himself, with his Pupil Giotto; behind it Arnolfo Di Lapo, Gaddo Gaddi, Andrea Tafi, Niccola Pisano, Buffalmacco, and Simone Memmi; in the Corner Dante* (plate 9). He made studies of figures dressed in medieval costume for both pictures on the same sheets of paper, exploring in his imagination these two different scenes of Italian life in the Middle Ages. However, early in 1854 he wrote to Steinle informing him of his decision to increase the size of the projected *Cimabue's Madonna*, ostensibly because his eyesight, about which he was neurotically worried as a young man, was not up to working on a small scale: 'I therefore took a canvas of 17½ feet (English measure), in consequence of which my figures have become half life size (like Raphael's "Madonna del Cardellino"), and do not look at all ill.' At this stage he was still hopeful for *The Reconciliation*, but accepted that 'its necessarily serious and dingy aspect' would always make it less popular.

Cimabue's Madonna was in many ways quite different from *The Reconciliation*: instead of a death-bed scene Leighton has chosen a subject which is festive and celebratory; furthermore, the subject is set out of doors and he was able to paint the costumes, and the architecture and landscape of the background, in brilliant colour. The scene represented is taken from Vasari, who describes the procession of the *Rucellai Madonna* (now identified as the work of Duccio rather than Cimabue) to the church of Santa Maria Novella. Cimabue is seen at the centre, walking proudly before his masterpiece, hand in hand with his pupil Giotto. Standing on the right Dante observes the scene. The striped marble wall suggests the marble cladding of Santa Maria Novella; in the background is the Florentine landmark of San Miniato.

This painting was a major undertaking and demonstrates the thoroughness of Leighton's artistic training in Germany. He corresponded with his old master Steinle about how he might treat the subject, and showed him cartoons of what he intended when he visited Frankfurt in the summer of 1853. He also sought advice from other German artists in Italy. Early compositional designs show the procession moving from the right and without turning towards the viewpoint at the left-hand side, but Cornelius recommended that 'to prevent the picture being too frieze-like' he should 'allow the foremost group to walk up to the spectator'. This device is perhaps not well managed; Leighton has set the line of figures too low down in the composition to allow a convincing display of perspective. The details of the painting were meticulously prepared. Leighton consulted

14

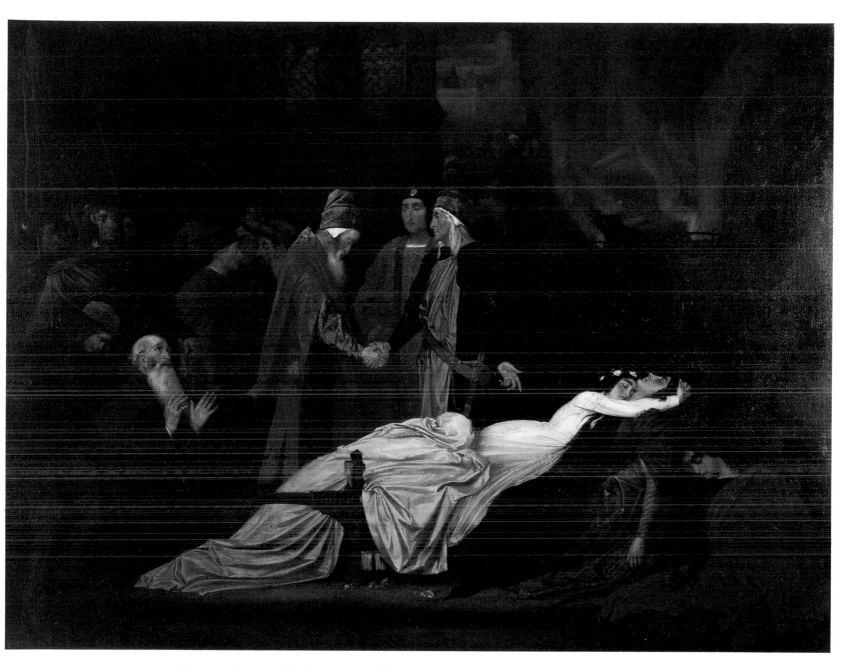

7. *The Reconciliation of the Montagues and Capulets over the Dead Bodies of Romeo and Juliet*. 1853–5.
Oil on canvas, 70 × 91 in. (177.8 × 231.1 cm.). Agnes Scott College, Decatur, Georgia

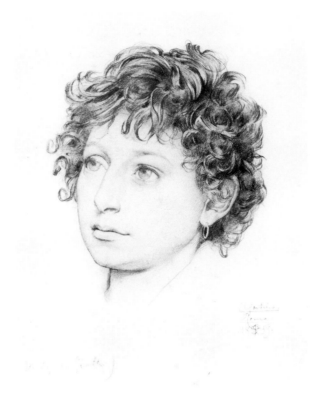

8. Study of the head of a model called Agostino, for the figure of Giotto in *Cimabue's Madonna*.
Pencil on white paper, 8³/₄ × 6⁷/₈ in. (22.2 × 17.4 cm.). British Museum, London

illustrated editions of Vasari's *Lives of the Painters* for some of the portraits; others such as the head of Giotto were based on drawings he had made of Roman models (see plate 8).

Cimabue's Madonna is the first of a series of great processional paintings which Leighton was to undertake at intervals during his career, and in it are introduced a number of formal devices upon which he was to rely. The two figures of Cimabue and the boy Giotto at the centre of the composition are carefully separated from the figures around them, both physically and psychologically. Their isolation is heightened by the simplification of the background immediately behind them; in early drawings a pair of plant pots standing on the wall above their heads mark their separation from the rest of the party, a device which was eventually dispensed with.

In this work Leighton made his first attempt at the large-scale symmetry which was to become a characteristic of his paintings. The elements of the composition are matched across a vertical dividing line which runs through the figure of Cimabue: the Madonna is balanced by the gothic niche on the background wall; the figures are arranged in corresponding groups across the width of the composition; and at either end a figure is raised up to terminate the scheme. (In the early drawings both were to consist of equestrian figures, but Leighton must have eventually considered this too obvious and in any case how was the left-hand horseman to be placed without facing directly out of the composition? Leighton substituted the man who lifts a child on to his shoulders on the left.)

The painting reveals Leighton's extraordinary skill in manipulating and drawing together the elements of a composition by carefully controlling the linear dynamics as well as the spatial distributions. Monotony is avoided by apparently casual interruptions of the overall pattern, but every detail is a vital constituent of the complete scheme.

Cimabue's Madonna depends upon a number of influences and prototypes. The processional paintings of Carpaccio and Gentile Bellini, which Leighton had seen in Venice, may provide the distant ancestry; the colour and richness of texture prompted a contemporary audience to recognize a more general Venetian inspiration. Various early nineteenth-century German painters had painted the story of Cimabue's Madonna as related by Vasari; and contemporary Italian art fostered a tradition which celebrated the achievements of medieval and Renaissance artists. In a more general sense Leighton's formative experiences as a student in Germany inclined him towards a type of painting which described an event in public life and which celebrated the beneficial influence which art has upon a civilization. When he undertook *Cimabue's Madonna*, Leighton had in mind the example of large-scale paintings of earnest intent, such as Moritz von Schwind's *Consecration of Freiburg Cathedral*.

Leighton wrote years later that for him 'the love of medievalism, the youth of Art, which is almost invariably found in youths, was strengthened and nourished in me partly by an early love for Florence and Tuscan art in which all grace is embodied, and partly by the example of my master Steinle, for whom I had and have retained, a great reverence, and who was fervently mediaeval.' Not only was *Cimabue's Madonna* a celebration of Florentine art, it was a statement of the public prestige which an artist might attain.

Early in 1855 Leighton decided to send *Cimabue's Madonna* to the Royal Academy. He wrote to his father in February: 'Such is the party spirit of R.A.s, that the best chance of securing impartial treatment (in the case of a work of merit) is to be *completely unknown* to all of them, a condition which I am admirably calculated to fulfil.' The painting was accepted and the question arose as to how well it would be seen in the cramped and crowded exhibition rooms of the Royal Academy in Trafalgar Square: Leighton told his father: 'One thing is certain, they can't hang it out of sight – it's too large for that.'

In the event Leighton's first essay into the London exhibition forum was an astounding success: on the opening day of the Academy Queen Victoria bought the painting for 600 guineas. The Queen wrote of the purchase: 'There was a very big picture by a young man, called Leighton ... it is a beautiful painting quite reminding one of a Paul Veronese, so bright and full of lights. Albert was enchanted with it, so much that he made me buy it.' The Prince Consort was predisposed to favour a work which owed so much to German and Italian art.

The acquisition of the painting for the Royal Collection thrust the young artist into the limelight and for the first time he was the object of critical attention. John Ruskin made the case that *Cimabue's Madonna* fulfilled the very principles which he had laid down for Pre-Raphaelite painting: 'This is a very important and very beautiful picture', he wrote. 'It has both sincerity and grace, and is painted on the purest principles of Venetian art – that is to say, on the calm acceptance of the whole of nature, small and great, as, in its place, deserving of faithful rendering.'

Other factions seized upon *Cimabue's Madonna* as a weapon in the heated polemic which continued to divide the Victorian art world into supporters and opponents of the Pre-Raphaelites. The *Art Journal* believed it signified a change in the course of English painting: 'It is easy to predict that, out of this triumphant achieve-

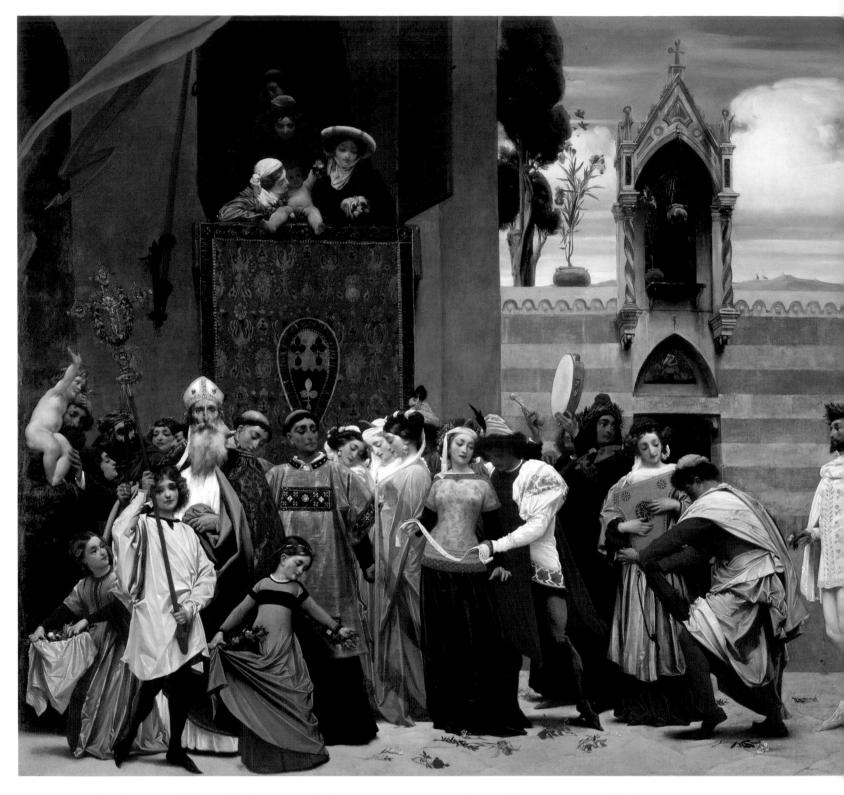

9. *Cimabue's Celebrated Madonna is carried in Procession through the Streets of Florence; in front of the Madonna, and crowned with Laurels, walks Cimabue himself, with his Pupil Giotto; behind it Arnolfo Di Lapo, Gaddo Gaddi, Andrea Tafi, Niccola Pisano, Buffalmacco, and Simone Memmi; in the Corner Dante.* 1853–5.
Oil on canvas, 87¹/₂ × 205 in. (222.2 × 520.5 cm.). Royal Collection (on loan to the National Gallery, London)

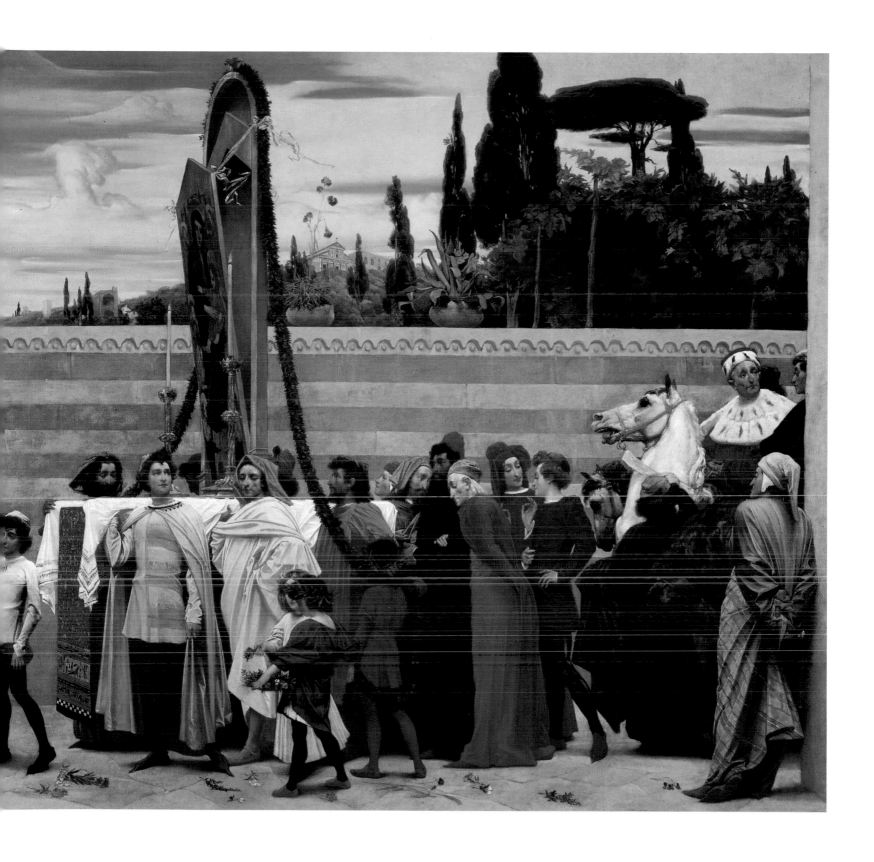

ment, and the fame it must undoubtedly secure for its producer, a more wholesome style will prevail, and influence our "school:" avoiding, as it does so thoroughly, the errors of a past, and the evils of a present, "mode" of painting . . . We date hence a higher, healthier, and more national aim at excellence.' The less reactionary *Athenaeum* made a nice distinction between literal and stylistic interpretations of Pre-Raphaelitism, calling *Cimabue's Madonna* 'One of the finest pictures in the Exhibition – painted in the true, as distinguished from the modern, Pre-Raphaelite style'. The Pre-Raphaelites themselves knew that Leighton's painting was being seized upon by their detractors; Dante Gabriel Rossetti wrote to William Allingham:

> There is a big picture of *Cimabue*, one of his works in procession, by a new man, living abroad, named Leighton – a huge thing, which the Queen has bought, which every one talks of. The R.A.s have been gasping for years for some one to back against Hunt and Millais, and here they have him; a fact which makes some people do the picture injustice in return. It was *very* uninteresting to me at first sight; but on looking more at it, I think there is great richness of arrangement – a quality which, when *really* existing, as it does in the best old masters, and perhaps hitherto in no living man – at any rate English – ranks among the great qualities.

Rossetti made a further perceptive comment, and one which was to anticipate criticism of Leighton's paintings in the future: 'The choice of subject, though interesting in a certain way, leaves one quite in the dark as to what faculty the man may have for representing incident or passionate emotion.'

Leighton perhaps realized that he was being drawn into an internecine battle; he certainly knew that *Cimabue's Madonna* was going to be a hard act to follow, for he wrote: 'My *succès*, here in London, which, for a beginner, has been extraordinarily great, fills me with anxiety and apprehension; I am always thinking, "What can you exhibit next year that will fulfil the expectations of the public?"'

It is worth inquiring how *Cimabue's Madonna* operates. As has been seen, Leighton combined an eclectic range of influences with his own precocious aptitude for composition to create a modern painting in medieval guise. Its fundamental classicism, and its essential modernity, lie in its formal characteristics: its frontality and symmetrical balance of composition, and its dependence upon carefully controlled areas of colour over linearity. Leighton owed as much to his study of Raphael and Leonardo for the organization of the picture's figures in a single plane within an architectonic setting, as he did to the Venetians for the richness of surface. Primitive styles of painting tend to depend upon the frontal plane for their distribution, while classical styles generally utilize planes and avoid areas of recession within their compositions. Leighton, who may still have been emulating a specifically archaic type of painting, as practised by the Nazarenes for example, in fact created in *Cimabue's Madonna* a formally classical work. In 1852 he had written enthusiastically of the gothic architecture of the newly built Houses of Parliament: 'The example they set of building in that style of architecture which is our own, the growth, as it were, of our soil, and which therefore best befits our country.' *Cimabue's Madonna*, like the Palace of Westminster, combines gothic motifs with a classical structure.

Two close friends of Leighton, whom he first met in Rome, were the Italian Giovanni Costa and the Englishman George Heming Mason, both landscape painters. The three painted and sketched together – J.E. Staley described how they 'made frequent excursions on foot into the Campagna, and whilst Mason drew cattle and sheep, Leighton made sketches of their guardians, and also of plant-life.' Leighton's drawings of plants

and objects are immaculate records, quite as objective in their truth to nature as anything done by the Pre-Raphaelites. At an early stage in his stay in Rome he had written of his desire to record nature, misquoting Ruskin's edict from *Modern Painters*: 'I long to find myself again face to face with Nature, to follow it, to watch it, and to copy it, closely, faithfully, ingenuously – as Ruskin suggests, "choosing nothing, and rejecting nothing".' Leighton occasionally undertook pure landscape subjects at this stage, but his desire to study nature was principally as a training for his work as a painter of figurative subjects. He concluded: 'I have come to the conviction that the best way for an historical painter to bring himself home to Nature, in his own branch of the art, is strenuously to study landscape, in which he has not had the opportunity, as in his own walk, of being crammed with prejudices, conventional, flat – academical.'

When Leighton moved to Paris in 1855 (he was installed in a studio in the rue Pigalle by September of that year) he associated with a group of younger French painters, some of whom he had already known in Italy. Costa recalled how Leighton 'fell under the influence of the romantic French school of colourists, such as Robert Fleury: and later again, of the French naturalists, above all [Gabriel] Decamps and [Ernest] Hebert.' In 1856 Leighton visited Barbizon on several occasions, and there made friends with Jean-François Millet and Jean-Baptiste Camille Corot. These contacts with contemporary French landscape painting explain to some extent the new freshness of colour and atmosphere in Leighton's work, and set the pattern for his style of landscape painting.

In Rome Leighton had been in contact with his near contemporary Adolphe-William Bouguereau. The Frenchman was already attempting the type of thematic classical subjects upon which his later career was to be based. It may have been Bouguereau's influence which persuaded Leighton to live for a while in Paris; it seems likely that it was he who introduced Leighton to the circle of writers and critics, including Baudelaire and Gautier, who first fostered the idea of *'l'art pour l'art'* – that is, an art which served the artist's search for a more refined and harmonious expression of beauty, and to which the spectator looked, not for information, but for the gratification of the senses. These theories were original enough in the intellectual context of France, even if French rococo painting had had a similar purpose. In England, where art had traditionally served in the display of material possessions, the principle was revolutionary.

Leighton started a number of new pictures in Paris in 1855–6, including another subject from *Romeo and Juliet*, *Count Paris comes to the House of the Capulets to claim his Bride* (Adelaide, Art Gallery of South Australia), and *The Fisherman and the Siren – from a Ballard by Goethe* (Bristol City Art Gallery), but neither was completed in time for the Academy exhibition of 1856. He did, however, send one picture, *The Triumph of Music: Orpheus by the Power of his Art redeems his Wife from Hades* (untraced).

Leighton's forebodings about how his subsequent works might be received after the success of *Cimabue's Madonna* proved well founded. *The Triumph of Music* was a complete failure, badly hung at the Academy, but by no means ignored by the critics, who derided the anachronism by which Leighton had given Orpheus a modern violin rather than a lyre. Objection was also made to the mythological, or 'pagan' subject; and the style was regarded as being overtly French, a damning criticism to make of any English painting in the middle years of the century. Because the finished painting is lost (only a colour sketch survives as a record of the composition [plate 12]) it is hard to know whether the criticisms were justified, or the result of a general feeling of public hostility towards Leighton, or simply the consequence of a sense of anticlimax following his previous success. What is certain is that the artist was greatly disheartened; he wrote to his parents: 'My picture, which has been

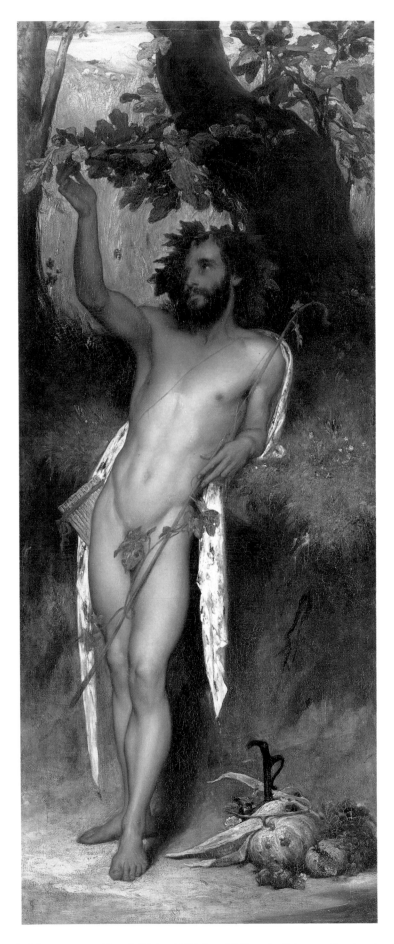

10. *Pan*. Exhibited 1856. Oil on canvas, 60 × 24¹/₂ in. (152.5 × 62.2 cm.). Private collection (on loan to Leighton House)

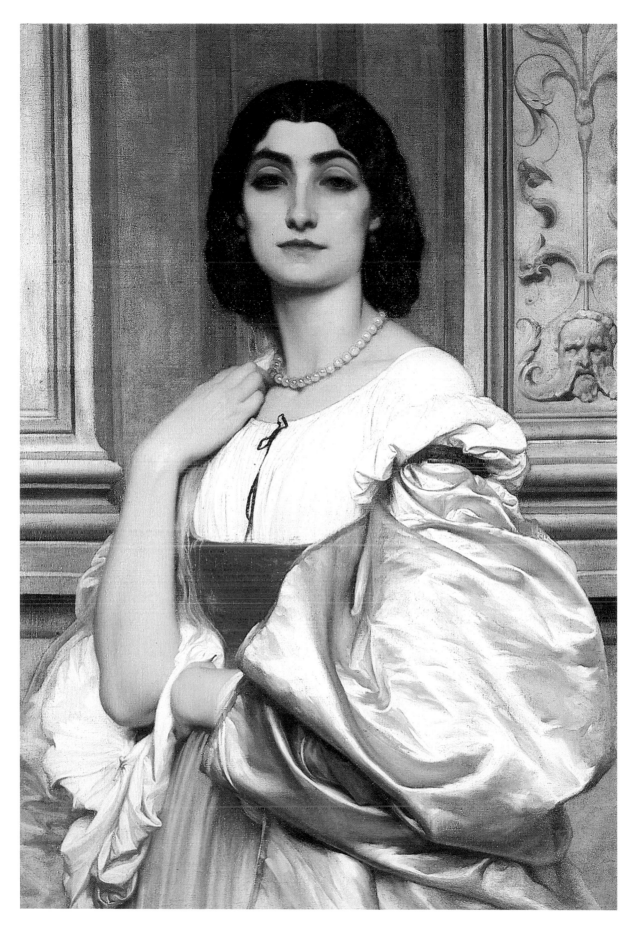

11. *A Roman Lady (La Nanna)*. 1859. Oil on canvas, 31$\frac{1}{2}$ × 20$\frac{1}{2}$ in. (80 × 52 cm.).
Philadelphia Museum of Art (Henry Clifford Memorial Fund)

12. Sketch for *The Triumph of Music. c.* 1855. 10¹/₂ × 15¹/₄ in. (26.8 × 38.5 cm.). On loan to Leighton House, London

exceedingly badly hung, so that one can scarcely see half of it (indeed I believe only the figure of Orpheus), is an *entire failure*; the papers have abused, the public does not care for it, in fact it is a ''fiasco''.' The practical consequence of this setback was that he decided to stay away from London. He spent the next three years, from 1856 to 1859, in Paris; a sojourn which was to prove crucial in the evolution of his early style of painting and personal theory of aesthetics.

A painting which gives a clue to Leighton's artistic inclinations in these years is *Pan* (plate 10). The work illustrates lines from Keats's poem *Hymn to Pan*: 'Oh thou, to whom/Broad-leaved fig-trees even now foredoom/ Their ripen'd fruitage.' A watercolour sketch of the subject, dated 1855 and perhaps done in Italy, was given by Leighton to his adored friend Adelaide Sartoris. The oil version, and its companion *Venus and Cupid* (untraced), were first exhibited at the Manchester Royal Institution in 1856.

These three paintings, *The Triumph of Music*, *Pan* and *Venus and Cupid*, confirm Leighton's progression from an essentially backward-looking medievalism – which was deliberately archaic and romantic in its associations – towards a more modern and direct style.

The representation of the naked figure of *Pan* startled many of Leighton's contemporaries. Robert Browning, with whom Leighton had made friends in Rome, conveyed something of the physical presence of the work in a letter of January 1856: '[Leighton] has a capital Pan enjoying himself in a dell, from a superb Italian model here, (the perfection of a man,) and a Venus, very clever too; and designs for perhaps a dozen delicious pagan figures; a sudden taste that has possessed him.' Leighton first showed *Pan* and *Venus* in London at the studio of his friend the painter George Frederic Watts in Little Holland House. Watts was generous in his praise

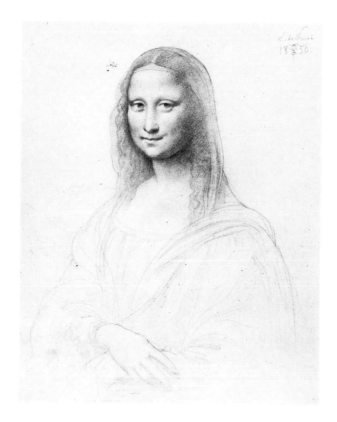

13. Study of the *Mona Lisa* by Leonardo da Vinci. 1856. Pencil on white paper, 9 × 7 in. (22.8 × 17.8 cm.).
Owen Edgar Gallery, London

of them: '. . . just as I expected, so far as being a foil to mine, they make mine by comparison look flat and dim. There are some wonderful things in them evincing a wonderful perception of natural effects.' On the whole Leighton's friends approved the directness and naturalism of *Pan*, even if Browning described its nakedness as 'properly idealized'. But the pictures were too much for the provincial audience to which Leighton had offered them. In Manchester they did not sell, and in New York and Philadelphia, where Leighton hoped they would be included in the American Exhibition of British Art of 1858, they were hidden away as unfit for public display.

During the winter of 1858–9 Leighton returned to Rome, where he painted a series of half-length figure subjects based on the Roman model Nanna Risi, who was known as 'La Nanna'. None of them is large in format; all are psychologically compelling. The version known as *A Roman Lady (La Nanna)* (plate 11) is about two-thirds life size. The composition is carefully thought out: the model's body and arm form a triangle with her pale-complexioned face at its apex; and the predominantly diagonal lines of her body are contrasted with the severe grid of verticals in the background. The architectonic device of framing pilasters serves to emphasize the impression of the model's height; despite the relatively small scale of the painting La Nanna seems to tower over the spectator. The painting incorporates astonishing passages of drapery painting: an extravagantly bunched satin cloak of creamy grey colour bordered with a piping of pale pink occupies a large part of the lower half of the painting, its brilliant glossy surface contrasting with the more modest white chemise and pink skirt, as well as with the bare skin of La Nanna's right forearm.

The unsmiling and sexually charged beauty of this woman is reminiscent of the ambivalent expression of the *Mona Lisa*, of which Leighton had made drawn studies in Paris in 1856 (see plate 13); her statuesque pose

25

14. *Garden of an Inn, Capri.* 1859.
Oil on canvas, 19¹/₄ × 26¹/₄ in. (48.9 × 66.7 cm.).
Birmingham Museum and Art Gallery

is derived from the paintings of Pontormo. The model's relentless and disarming gaze speaks of her strength of will, and yet she seems to remain indifferent to the feelings she inspires in the spectator.

In the spring of 1859 Leighton wrote to his mother: 'I am just about to despatch to the Royal Academy some studies from a handsome model, "La Nanna." I have shown them to a good many people, artists and "Philistines," and they seem to be universally admired. Let us hope they will be well hung at the Exhibition.' Three paintings were accepted, including *A Roman Lady*. Another in the series is called *Pavonia* (plate 1) in reference to the peacock-feather fan which La Nanna languorously holds against her face. On this occasion the model turns towards the spectator, not in a spontaneous or animated way, but reluctantly, to reveal the beauty of her face and neck to the artist. Again Leighton finds opportunity for the bravura painting of materials, and La Nanna's pearls, deep pools of milky luminescence each lit by a point of reflected light, are here dressed in her hair.

The paintings of La Nanna were applauded in London, and one was bought from the Academy by the Prince of Wales. Of those exhibited at the Academy the *Athenaeum* critic wrote:

> Mr. Leighton, after a temporary eclipse, again struggles to light. His heads of Italian women this year are worthy of a young old master, – so rapt, anything more feeling, commanding or coldly beautiful we have not seen for many a day . . . This is real painting, and we cannot but think that a painter who can paint what he sees so powerfully will soon be able to surpass that processional picture of his [*Cimabue's Madonna*] about which there was such a primitive charm and saintliness. It is a pity if such a spring has no summer.

This praise should not be taken as an indication that Leighton was established on the contemporary art scene. Earlier in the spring the painter had suffered a setback, as he described with affected indifference to his mother: 'You will be rather amused to hear that my "Samson" has been *refused* at the British Institution, which this year is particularly weak and insignificant. It is gone into the Suffolk Street [The Society of British Artists] now, unless too late.' The rejection of *Samson and Delilah* (untraced) by the admittedly old-fashioned British Institution was more of a blow than Leighton was prepared to admit.

Leighton's relations with the Pre-Raphaelites, with whom he had been in contact in 1855 and again in the summer of 1856, combined personal friendliness with a strain of suspicion which amounted to professional rivalry. In January 1860 Leighton wrote in a postscript to a letter to Browning: 'I am hand-in-glove with all my enemies the pre-Raphaelites'; and twenty years later he recalled that 'Millais, Rossetti, [and] Hunt were most cordial and friendly tho' I openly told them that I was wholly opposed to their views.'

It may be that Leighton's style of painting, which was naturalistic rather than realist, and predominantly figurative where theirs was generally concerned with the settings in which figures might appear, had a stylistic impact upon the Pre-Raphaelites. Holman Hunt, who in technical terms was the most loyal to the precepts of the Pre-Raphaelite Brotherhood, was certainly impressed by Leighton's work: in 1860 he wrote to Thomas Combe about the exhibition at the Hogarth Club, of which both Leighton and the Pre-Raphaelites were members: 'Some works by Leighton will deserve your especial attention – two outline designs seem to me to have great beauty in them – the small painted heads [of La Nanna] seem to me not so healthy in color as most of his pictures – he is a very true artist with different aims to my own but of a kind which I can admire highly when pursued with the painterlike power displayed by him.'

Figure 1. Photograph of Frederic Leighton, *c*. 1860, by David Wilkie Wynfield (1837–87) National Portrait Gallery, London

Rossetti was perhaps the most affected by Leighton's paintings – possibly because they struck him at a moment when he was uncertain of what course he should follow. Shortly after seeing Leighton's La Nanna series he commenced the luxuriant and deliberately erotic half-length paintings of young women, such as *Bocca Baciata*, which set the pattern for his later career. Leighton may have kept his distance from the painters who were adapting Pre-Raphaelitism to the purposes of the Aesthetic Movement, but he made a major contribution by inventing the apparently straightforward but psychologically compelling paintings of women which Rossetti, Frederick Sandys, Albert Moore, and others were to adopt in the 1860s.

In the early summer of 1859 Leighton travelled to the south of Italy to spend five weeks painting and sketching landscape subjects. The series of small oil studies which he made of buildings and streets in Capri, including *Garden of a House at Capri* (plate 15), were mementoes of the fall of sunlight across the structures of the clustered houses. The white-painted walls and stairways absorb the brilliance of the light; while the dark foliage of the tropical vegetation throws off sparkling reflections. On a somewhat larger scale is *Garden of an Inn, Capri* (plate 14). These are the first works which Leighton painted for his own pleasure and without regard for critical opinion.

15. *Garden of a House at Capri.* 1859. Oil on canvas, 12^{1}/$_{2}$ × 10^{1}/$_{8}$ in. (31.8 × 25.7 cm.). Loyd Collection

16. *The Wine Press.* Early 1860s. Watercolour, $4^1/_2 \times 6^3/_4$ in. (11×17 cm.). Private collection

Equally personal, but perhaps a more self-conscious exercise, is the extraordinary and celebrated drawing *A Study of a Lemon Tree* (plate 98). Years later, Leighton described 'the difficulty [he] experienced in finding again and again each separate leaf in the perspective of the confused branches, as morning after morning [he] returned at sunrise to continue his work.' The drawing carries the Ruskinian principle of minute observation to the ultimate degree; and yet it is more than a meticulous botanical record – the leaves seem almost to flutter in the Mediterranean breeze, and the snails shown in a cluster in the margin appear ready to crawl back into the branches of the tree.

Ruskin loved this drawing; when he first saw it at the Hogarth Club in 1860 he was prompted to write to Leighton: 'Unless I write again I shall hope to breakfast with you on Friday, and see and know evermore how a lemon differs from an orange leaf.' Twenty years later he cited it as a vital formative stage in Leighton's career: 'which determine[s] for you without appeal the question respecting necessity of delineation as the first skill of a painter. Of all our present masters, Sir Frederic Leighton delights most in softly-blended colours, and his ideal of beauty is more nearly that of Correggio than any since Correggio's time. But you see by what precision of terminal outline he at first restrained and exalted his gift of beautiful *vaghezza*.'

Leighton was seeking at this early stage in his career to gain complete technical command of the various media of pictorial art. Not only did he produce highly worked pencil drawings which were admired by his contemporaries, he also worked in watercolour, which some considered not suitable for the professional artist. *The Wine Press* (plate 16), done in Paris in about 1859, shows the type of decorative ensembles which he considered appropriate for the medium.

In the autumn of 1859 Leighton finally settled in London. A painter friend, Alfred Elmore, helped him to find a studio in Orme Square, which Leighton described as 'narrow and dark', 'after Paris and Rome . . . a sad falling off'. In different ways he found life in London inconvenient and expensive: 'models are five shillings a sitting here – ruination! – men with good heads there are none – women, tol lol! – a lay figure twenty-five shillings a month; in short, historical painting here is not for nothing.' Despite these difficulties he was on the whole pleased to be in England, or so he wrote to Browning: 'You would not believe it, in spite of my old habits of continental life and sunshine, I take very kindly to England; *it agrees* with me capitally, really better than Rome. I am fattening *vue d'oeil*. The light is certainly not irreproachable, still I can work, and don't find that my ideas get particularly rusty. On the contrary, for colour, certainly my sense seems to be sharpened by this atmosphere.'

Although Leighton's father was a comparatively rich man, and prepared to support his son, he was not especially generous and the allowance that he provided had to be accounted for in detail. Leighton probably never relied solely upon his income as an artist, and yet he was strongly motivated to exhibit and sell his paintings; with very few exceptions the only pictures he held on to were ones which he had failed to sell commercially, and these he was often prepared to sell cheaply to cut his losses. His drawings and sketches were another matter; these were carefully put away for future perusal and provided him with a repertoire of forms.

Like most English artists who needed to earn their living, Leighton accepted portrait commissions, although generally only from people he knew quite well. He was befriended by various distinguished families and he enjoyed staying in country houses; in return he painted elegant portraits of his hostesses. At Stourhead, in the late 1850s, he made likenesses of both Lady Hoare and of her daughter (plate 17), and a few years later he painted the members of the Cowper family at Panshanger. Leighton was socially ambitious and enjoyed fashionable life; he also took the opportunity to study the great works of art which hung in the aristocratic houses to which he was invited.

Leighton's attachment to Adelaide Sartoris, who had done so much to launch him in society, led to his painting her daughter May Sartoris (plate 18). The Sartorises moved about Europe with as much freedom as Leighton did himself, but in 1859 the family had set up at Westbury House in Hampshire, and it was there that the portrait of May was done. The sixteen-year-old girl is seen advancing towards the spectator holding her heavy blue skirts out of the chalky roadway; she wears a wonderful feathered hat and a bright red scarf. Her expression speaks of self-confidence and intelligence.

Whenever Leighton placed figures in landscape settings, in portraits or in invented subjects, he looked for ways to obscure the transition from foreground to distance. For this reason he placed a felled tree trunk across the path along which May Sartoris is walking in the portrait. The landscape, which was constructed from sketches done in the open air at Westbury, is handled with considerable painterly freedom. In the distance is a church beneath trees, a field of standing corn stooks, and at the left at the extreme top of the picture space, a windmill. Such a vivid evocation of the English countryside is rare in Leighton's work.

One of the largest and most important of Leighton's six exhibits at the Royal Academy in 1861 was *Lieder ohne Worte* (plate 19). The painting was originally to be called 'The Listener'; the adoption of the title of Mendelssohn's collection of piano pieces which, as 'Song without Words', were popular in England in the 1850s and 1860s, was an afterthought suggested by a friend. A girl, loosely dressed in flowing draperies, lounges languorously while her pitcher fills from an ornately decorated cistern. Above her head a bird sings, but whether

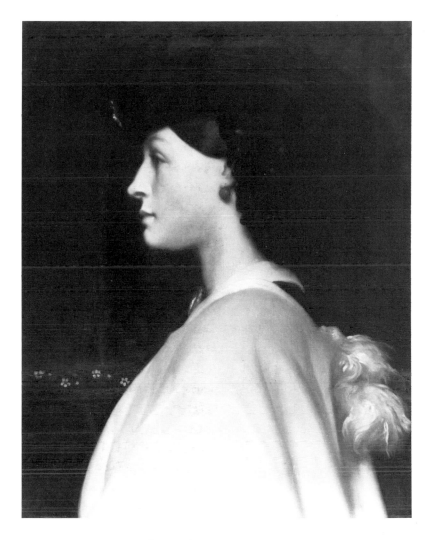

17. *Augusta Hoare*, 1860. Oil on canvas, 23½ × 18¼ in. (59.7 × 46.4 cm.). The National Trust, Stourhead House.

she hears the song or her thoughts remain undisturbed, is not clear. On the left side a smaller but statuesque figure, carrying vessels of water in both hands and with another balanced on her head, ascends a marble staircase. The painting seems to invite the spectator into the hermetically and compositionally closed space which the women occupy, to savour their wistful and abstracted mood. One strains to catch the sound of the bird's song as well as to hear the plashing of the stream of water.

Leighton was moving towards a greater abstraction of the physical appearances of people and places. The girl's face in *Lieder ohne Worte* was based on studies of a boy called John Hanson Walker, but Leighton departed from the actual model in favour of an ideal of physiognomic beauty. Similarly, the setting represents no specific place but rather offers a vision of a marble-clad palace in the Mediterranean south. To his father, who tried to advise his son how to make his paintings more acceptable to general taste, Leighton wrote: 'I remember, it is true, telling you *before* I began to paint "Lieder ohne Worte" that I intended to make it *realistic*, but from the first moment I began I felt the mistake, and made it professedly and pointedly the reverse.' Prosaic detail was incompatible with the classical style to which he was striving in the 1860s.

Despite Leighton's desire to distance the settings of his paintings from a recognizable time and place, he was meticulous about the construction and harmonious arrangement of the elements of his compositions. In

33

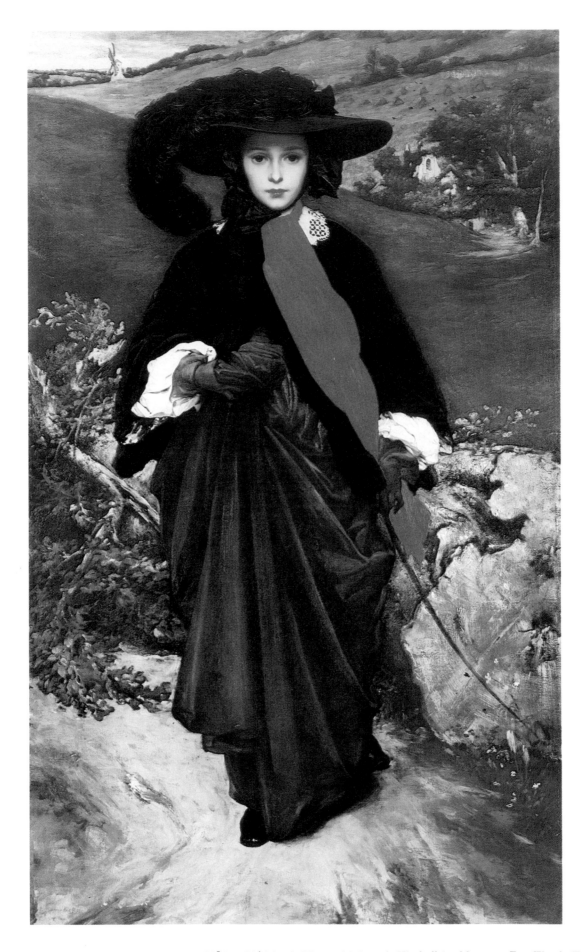

18. *May Sartoris. c.* 1860. Oil on canvas, 59⅞ × 35½ in. (152.1 × 90.2 cm.). Kimbell Art Museum, Fort Worth, Texas

19. *Lieder ohne Worte*. Exhibited 1861. Oil on canvas, 40 × 25 in. (101.6 × 63.5 cm.). Tate Gallery, London

the case of *Lieder ohne Worte* he made careful drawings of the draperies and the carved stone mouldings, and of the curiously twisted posture of the girl. Detailed studies were made of the model's hands, which are so important in conveying the mood of the painting.

As Leighton sought to gain wider public acclaim for his art he became increasingly anxious to leave no element of his painting to chance. This approach led to a lack of spontaneity and liveliness about his subjects, which was commented upon critically by his contemporaries. On the occasion of the rejection of *Samson and Delilah* Costa said that 'his friends . . . made [Leighton] see how he ought specially to value the spontaneity of

his work'; even Watts, another of Leighton's loyal friends, speculated 'how much finer Leighton's work would be if he would admit the accidental into it.'

Leighton felt that he was being treated unfairly by a faction of older painters within the Academy; certainly none of his exhibits in 1861 was well hung. Whether he was actually persecuted, or just the victim of a system whereby members of the Academy looked after their own interests before finding space for newcomers, is hard to say. Leighton was an arrogant young man – convinced of his own precocious talent and unforgiving of those who obstructed him. He was also infuriatingly effete; in 1861 George du Maurier exploded with irritation against him, following a meeting at an artists' party: 'Cimabue was there – I don't know whether you would like him, very blasé and finikin, and quite spoilt – one of the world's little darlings, who won't make themselves agreeable to anything under a duchess.' Alfred Stevens scornfully dubbed him 'that fop of an artist'.

However, in 1862 six of the eight works Leighton submitted to the Academy were accepted. One of these was *Sisters* (plate 22), a painting of great charm, showing a young woman, standing within a paved colonnade before a verdant garden, bending down towards a little girl. The title was again an afterthought; the painting might equally have represented a mother and daughter. Leighton has captured the excitement and warmth of feeling of an embrace, indeed the painting has no motif other than the expression of delight which the two feel at seeing one another: the elder of the two enfolds the younger protectively and maternally.

The woman's yellow silk dress, sumptuous in texture and brilliant in colour, is a marvellous piece of bravura drapery painting, undertaken for the sheer pleasure of its execution and to astound the spectator. The long folds of material flow from tightly folded pleats at the waist and cascade with glacial massiveness upon the marble pavement. As in his portrait of *La Nanna* the drapery is made to seem especially lustrous by the contrast with the neutral surfaces of the framing columns.

Sisters was a distinct success. Leighton reported that Millais, who had seen the painting before it was sent to the Academy, 'liked the yellow woman extremely. I think he liked them all [i.e. all of Leighton's 1862 exhibits] *of their kind*, but the yellow woman was his favourite by far.' *Sisters* was well hung and found a buyer in the person of Stewart Hodgson, and gradually Leighton began to feel more self-confident. Even before the 1862 Academy exhibition he was writing to his father: 'You will be glad to hear that I have received congratulations on all sides, which gives me the idea of being tolerably secure; at all events, I got no such last year, nor indeed at all since the "Cimabue".' He had learnt what went well with the public, writing in the same letter: 'There is no mistake now about what people in this country like . . .; whether I shall conform to their taste is another question.'

Religious subjects certainly did not recommend a painter to a wider public, and were generally avoided by artists with an eye to their commercial prospects. But Leighton considered subjects from the Bible an essential part of his repertoire if he was to raise the standards of public taste and fulfil the role in the artistic life of the nation which he sought. *The Star of Bethlehem* (plate 21), exhibited at the Royal Academy in 1862, was accompanied by an explanatory sentence in the catalogue: 'One of the Magi, from the terrace of his house, stands looking at the star in the East: the lower part of the picture indicates a revel, which he may be supposed to have just left.' Leighton was following the tradition of English Protestant art which preferred to show an imaginary scene based on Bible history rather than an event actually described in the Old or New Testaments or supported by traditional iconography. The arrangement of *The Star of Bethlehem* is dramatic and effective, but the

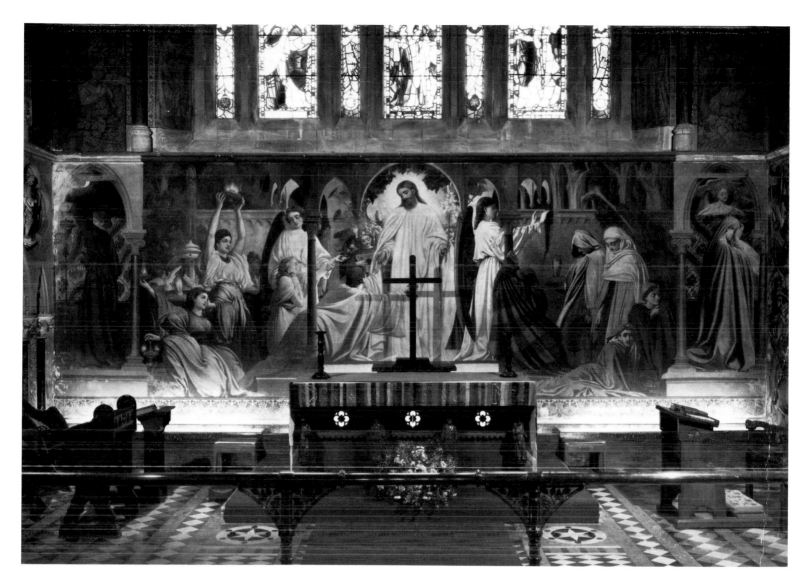

20. *The Wise and Foolish Virgins.* 1862–4. Spirit fresco, 96 × 288 in. (243.84 × 731.52 cm.).
St Michael's Church, Lyndhurst, Hampshire

painting was not well received. Having failed to sell it at the Academy, Leighton resorted to placing it in
Christie's saleroom.

 The Wise and Foolish Virgins (plate 20) – based on Christ's parable in Chapter 25 of St Matthew's
Gospel – was painted for St Michael's Church in Lyndhurst in the New Forest, and occupied Leighton inter-
mittently from 1862 to 1864. He adjusted the Biblical text to give both symbolic impact and compositional
symmetry to the mural: at the centre, framed by a circular arch and surrounded by music-making angels, is
Christ himself in the role of bridegroom. The Wise Virgins, those who had the foresight to bring supplies of oil
with them, are on the left, bathed in light and permitted to advance towards Christ and touch him. They
appear bare-headed and wearing light-coloured dresses; they inhabit an idyllic setting, where doves flutter
around a fountain, and a summer garden is glimpsed beyond. On the other side are the Foolish Virgins, seen in
a state of dark despair, prohibited from entry to the wedding-feast, or by implication the Kingdom of Heaven, by
an angel with raised hands. They are enveloped in fustian draperies and are surrounded by a scene of desolation,

37

21. *The Star of Bethlehem.* Exhibited 1862. Oil on canvas, 60 × 23¹/₂ in. (152.4 × 59.7 cm.). Private collection

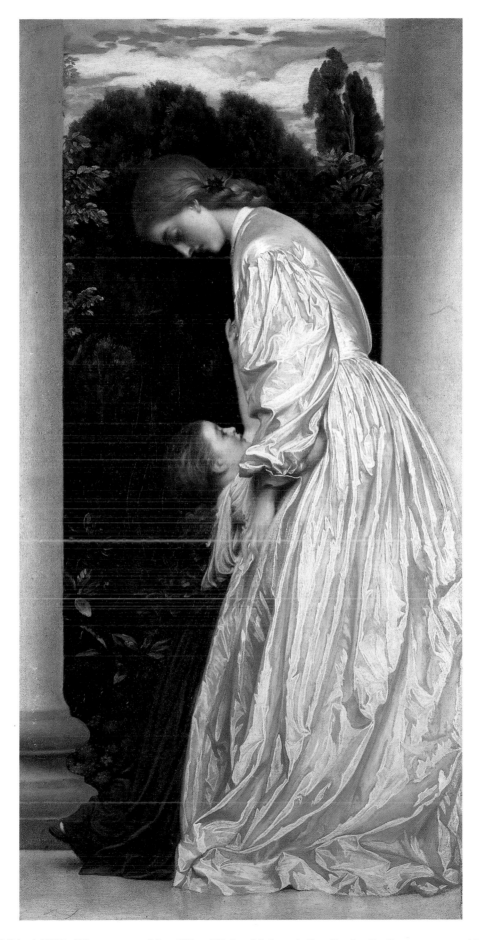

22. *Sisters*. Exhibited 1862. Oil on canvas, 30 × 15 in. (76.2 × 38.1 cm.). Pre-Raphaelite Inc., courtesy of Julian Hartnoll

where an owl symbolizes darkness and the landscape has been racked by storm. At the extreme left and right are figures representing Vigilance and Improvidence. The symmetrical arrangement provides a classical guise for the symbolical opposition of the parable.

The mural was on an even larger scale than *Cimabue's Madonna*, and Leighton resorted to various compositional devices which he had not used since then. The central figure provides a pivot about which the elements of the painting turn, and the two halves are compositionally balanced. Each group of Virgins is arranged to make a loose circle; their postures, and the patterns of their draperies and gestures, make a wide, flat triangle, at the apex of which is the head of Christ. The effect suggests an arrangement of sculptures within an architectural pediment.

In the middle years of the nineteenth century the competition for schemes of decoration for the new Palace of Westminster inspired a debate about which medium was most suitable for works of art which were to be displayed in public buildings. Leighton had experimented with fresco as a young man in Germany, and he shared the general perception that this medium was particularly well suited to didactic or uplifting schemes. Overtures had been made on Leighton's behalf in the 1850s to get official commissions for fresco paintings, but nothing had come of these. The opportunity to decorate St Michael's was the result of Leighton having himself volunteered to do the work rather than an enlightened commission on the part of the church.

The Wise and Foolish Virgins was painted in a material called spirit fresco, recently developed by Leighton's friend Thomas Gambier-Parry. It provided the same pale tonality as fresco and colours could be mixed or reduced in intensity by adding more of the base vehicle; furthermore, the technique allowed re-touching in lighter or darker colours over areas that had already dried, which is not possible with fresco proper. The medium suited Leighton. In August 1863 he wrote: 'I am delighted with my new fresco material (Parry's) – the effect is excellent – nearly as fine as real fresco. Everybody seems much pleased with what I have done, particularly the parson. I like it myself; I enjoy working at it immensely; it is my real element.' The great advantage of Gambier-Parry's invention was that the finished painting would withstand the dampness of the English climate; and Leighton's fresco at Lyndhurst has survived in good condition.

The work successfully ornamented William White's recently completed church, into which it was carefully integrated (the painted architecture appears to extend in perspective from the chancel). Leighton had suggested that the then little-known Edward Burne-Jones should make the stained glass: his East Window, which Leighton called 'a lovely piece of colour', rises above Leighton's fresco and provides a splendid if visually distracting display. The decoration of St Michael's represented an important departure for Leighton – an opportunity to apply his nascent classicism to an edifying and sombre purpose.

Another means by which Leighton sought to gain a wider audience for his art was as an illustrator. In the early 1860s there was a vast increase in the number of books and periodicals issued with black and white line plates and many young artists, as well as a legion of seasoned professionals, worked to supply the demand for designs for wood-block engravers.

Leighton's first commissions as an illustrator came from *Cornhill Magazine*; his drawings of *The Great God Pan* and *Ariadne* appeared as plates to accompany Elizabeth Barrett Browning's poems 'A Musical Instrument' and 'Ariadne at Naxos' in 1860. He also provided a series of twenty-six drawings and decorated initials to illustrate George Eliot's *Romola*, which was serialized in the *Cornhill* in 1862–3. The setting of the novel in fifteenth-century Florence was what perhaps suggested Leighton's name as the illustrator. At first

23. *Moses views the Promised Land*. 1861. Indian ink and black chalk, $8^{1}/_{4} \times 5$ in. $(21 \times 12.7$ cm.$)$.
Victoria and Albert Museum, London

George Eliot disapproved of Leighton's work, and relations between author and illustrator were uneasy; on one occasion Eliot told Leighton that she believed 'that the exigencies of [his] art must forbid perfect correspondence between the text and the illustration.' Eventually the two made friends and Leighton's designs were acknowledged to have contributed to the publication's commercial success.

Particularly powerful images were the nine Biblical subjects which Leighton made in 1863–4. These designs were originally commissioned by Joseph Cundall but eventually passed to the Dalziel Brothers and appeared many years later in *Dalziel's Bible Gallery*. The compressed format of the finished plate required designs which were simple and robust in their distribution and lighting – anything fussy or over-complicated would lack impact. In the interest of legibility Leighton expanded the scale of the figures. This was to prove a valuable lesson; in the future, when Leighton wanted to give his paintings compositional drama and psychological impact, he resorted to the simplicity of drawings such as *Moses views the Promised Land* (plate 23).

In 1863 Leighton exhibited the first of a series of paintings which treat episodes from the life of the Prophet Elijah, as recorded in the Book of Kings. The full title is *Jezebel and Ahab, having caused Naboth to be put to death, go down to take possession of his vineyard; they are met at the entrance by Elijah the Tishbite. 'Hast thou killed, and also taken possession?'* (plate 26). Although on a massively expanded scale it has the same dramatic quality as the Bible illustrations which Leighton was working on at this time. The figures are compositionally and psychologically divided by the edge of the open door, and each is so large in relation to the

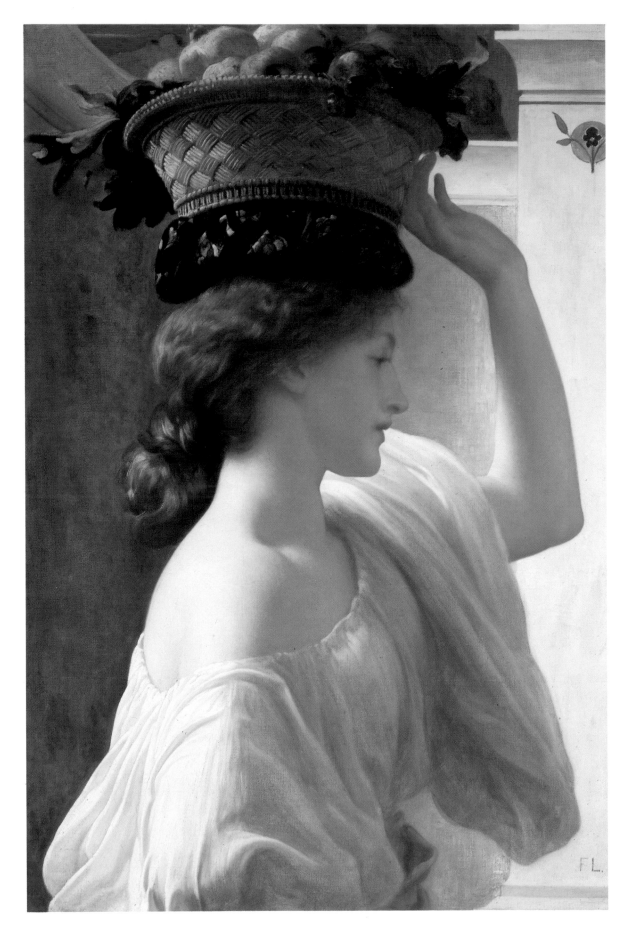

24. *Eucharis – A Girl with a Basket of Fruit*. Exhibited 1863.
Oil on canvas, 33 × 22³/₄ in. (83.8 × 57.8 cm.). Private collection

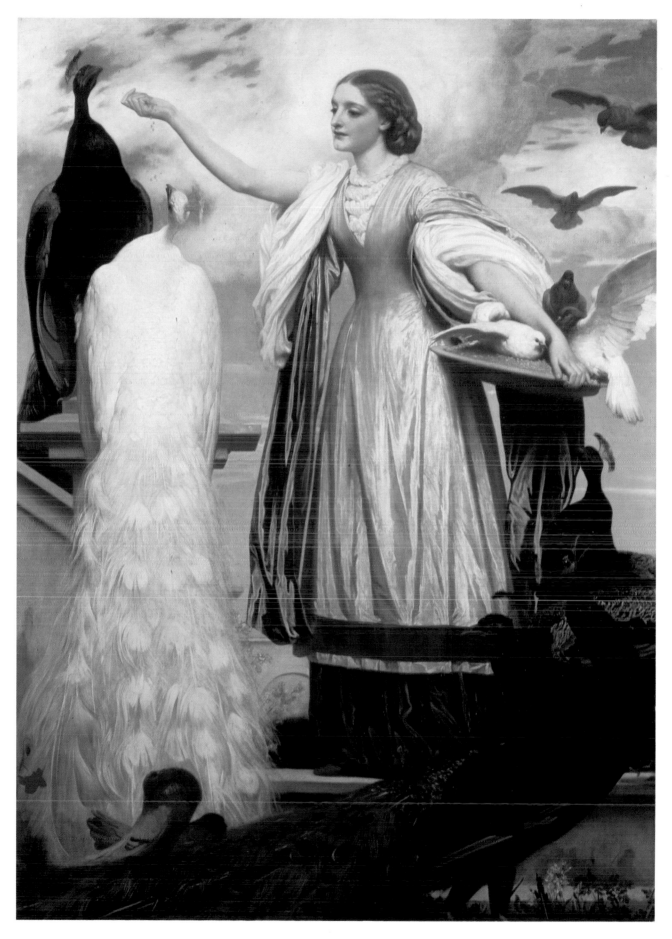

25. *A Girl feeding Peacocks*. Exhibited 1863. Oil on canvas, 74 × 63 in. (188 × 160 cm.). Private collection

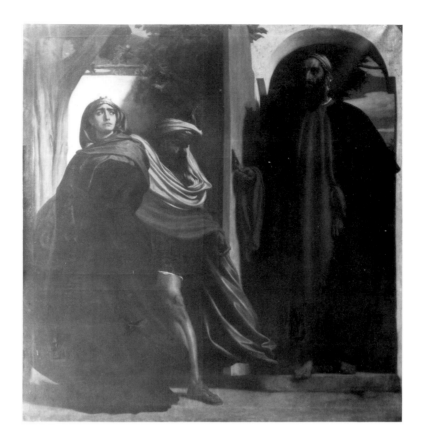

26. *Jezebel and Ahab, having caused Naboth to be put to death, go down to take possession of his vineyard;*
they are met at the entrance by Elijah the Tishbite. 'Hast thou killed, and also taken possession?'.
Exhibited 1863. Oil on canvas, 94 × 91 in. (238.8 × 231.1 cm.). Scarborough Art Gallery

overall size of the painting that subsidiary areas are severely restricted. The colours are sombre but effective: Elijah and Jezebel are dressed in brown and green cloaks; and she proudly wears a gold crown. Ahab is more lavishly atired; with an elaborate turban, a pink shawl and a bronze-coloured drapery hanging from his waist. A further touch of decorative colour is provided by the red cloth over his arms and the reddened vine leaves above the vineyard wall.

Leighton tended to restrict his figures to the immediate foregrounds of his paintings, so that they are seen in close physical conjunction and without the distraction of subsidiary vistas. A practical alternative to the frieze-like distribution of figures favoured by neo-classical artists (a formula which Leighton was to turn to) was to close the composition behind the figures and thus confine them to a foreground plane. In *Jezebel and Ahab, met by Elijah* he placed a wall across the background to ensure that the stage upon which his actors performed was suitably shallow, a device which had previously been seen in *Cimabue's Madonna* and *The Wise and Foolish Virgins*. The pictorial and dramatic impact of *Jezebel and Ahab, met by Elijah* is very great, even in its present darkened condition. The lighting, and the scale and simplification of the figures, are reminiscent of Bolognese classical painting of the seventeenth century and it is likely that Leighton had been looking at works by Guercino, Domenichino and Guido Reni when he conceived this composition.

Leighton's two other paintings at the 1863 Academy exhibition, *Eucharis – A Girl with a Basket of Fruit* (plate 24) and *A Girl feeding Peacocks* (plate 25), were more obviously decorative, and were applauded as such. William Michael Rossetti wrote of them: 'These belong to that class of art in which Leighton shines – the art of luxurious exquisiteness, beauty for beauty's sake, colour, light, form, and choice details for their own sakes, or for beauty's.'

In a sense *Eucharis* seems to conclude the line of development which Leighton began with the portraits of La Nanna of 1859. The sensuous delight which the painter takes in his exploration of the girl's neck and the flesh of her shoulders and upraised arm again suggests sources in Italian Mannerist art. The lighting must derive from his study of Caravaggio. The model's back rather than her face is illuminated, and this curious reversal of the expected equilibrium places her shoulder blades and the nape of her neck in silhouette against the dark background, and outlines her left forearm against a brightly lit pilaster; at the same time her profile is masked against a similarly shadowed area of the background.

Leighton continued anxiously to gauge the response made to each of his Academy exhibits. On this occasion he wrote to his mother: 'You would be pleased at the reception of my "Fruit Girl" by my brother artists – you must understand, though, that this applies chiefly to the younger men (and not to *all* of them), for there are several of the older painters who strongly object to my style of painting and are bent on suppressing it.' That *Eucharis* should have so divided Leighton's contemporaries is indicative of the radical departure that his paintings were seen to represent. Their naturalistic qualities were disturbing to traditional ideas of pictorial propriety, and the extravagant and sometimes contrary way in which he arranged the forms and lighting of his more self-indulgent paintings provoked painters of more stolid capabilities.

A Girl feeding Peacocks is the quintessence of Leighton's carefully composed, and essentially decorative, style of the 1860s. The sumptuous textures, both of the girl's dress, which is made of pink silk over a deep red velvet, with extraordinary greeny-blue pieces of material hanging down from the sleeves, and of the feathers of the peacocks, are a *tour de force* of painting. But if the subject was devised to delight the eye, its elements were closely observed and immaculately painted. Leighton's technical virtuosity made it possible for him to recreate the appearances of materials with astonishing accuracy; and yet he still delighted in the physical quality of the painted surface.

One of the unwritten precepts of the Aesthetic Movement was that narrative or circumstantial details should be excluded in favour of more abstract qualities. Mood and association of ideas, in combination with a harmonious arrangement of form and colour, were the means by which paintings should move the spectator. *A Girl feeding Peacocks* shows Leighton's commitment to these principles in the early 1860s.

Leighton became a candidate for election as an associate member of the Royal Academy in 1861, but year after year, and despite the number and importance of his Academy exhibits, he was passed over. There was still something about him which the old guard could not easily accept and he had certain influential enemies, not least the President, Sir Francis Grant. The Victorian art world was not yet polarized into pro- and anti-Academy factions, and alternative exhibition spaces were very few and not likely to appeal to Leighton's ambition for professional acclaim. He may have had friends among painters who were disaffected from the Academy – Watts, Rossetti and Burne-Jones, for example – but he, unlike them, believed implicitly in the essential usefulness of that institution.

27. *Dante in Exile*. Exhibited 1864. Oil on canvas, 60 × 100 in. (152.4 × 254 cm.).
British Rail Pension Trustee Company (on loan to Leighton House)

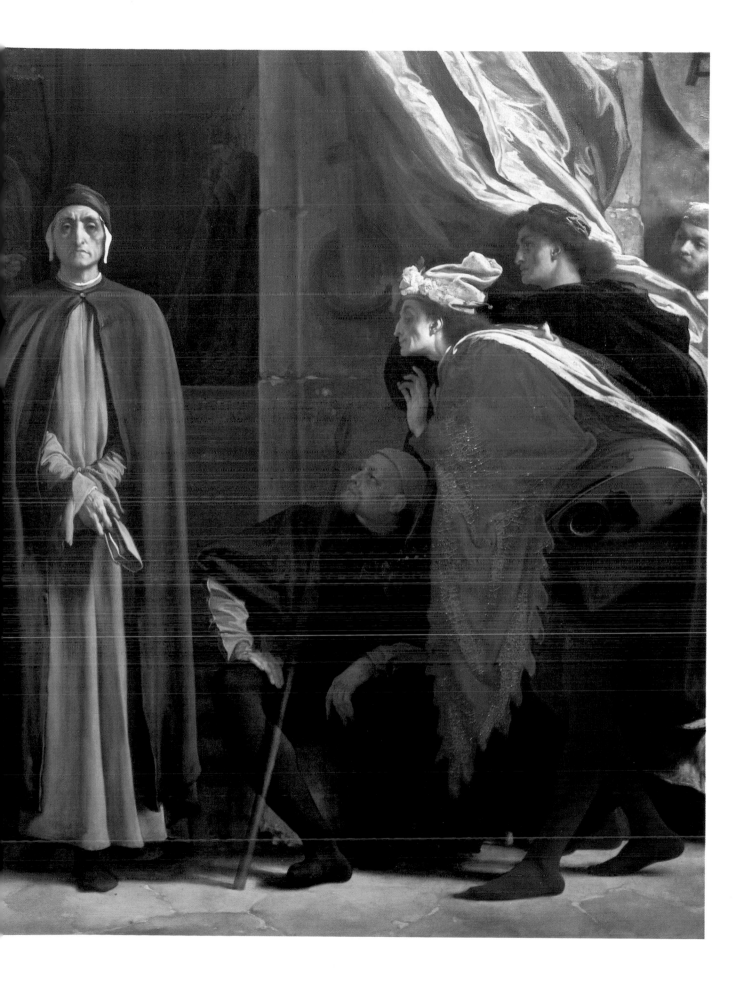

Leighton's three paintings at the Academy in 1864 represented the main types of subject which he had pioneered as a young artist. *Dante in Exile* (plate 27) is an elaborate and large-scale work showing the figure of Dante, who had been forced to leave his native Florence for Verona, mocked by a hostile crowd. Once again Leighton uses the compositional device of spacing the figures to indicate a psychological divide. In *Cimabue's Madonna* the central group was separated to make clear that they were the object of festive excitement; in *Dante in Exile* the same means is employed to emphasize Dante's loneliness and isolation.

Less successful than *Dante in Exile* was *Orpheus and Eurydice* (plate 28), an example of Leighton's mythological painting. The legendary figure of Orpheus, who played and sang so beautifully that all who heard him were captivated, even animals and plants coming under the power of his music, had also appeared in *The Triumph of Music*. In the later work Leighton shows Orpheus and his wife Eurydice on their way out of the Underworld. Eurydice is imploring him to face her, while he thrusts her away, apparently in revulsion, knowing that if he turns to look at her she will be lost to him for ever. The failure of *Orpheus and Eurydice* is not the result of its sexual or psychological ambiguity, but rather a consequence of its hysterical and yet frozen quality of theatricality.

As one of the painters of the Aesthetic Movement in the 1860s Leighton was also exploring themes of affection and intimacy, and of quiet companionship. *The Painter's Honeymoon* (plate 30) provides a counter to the idea that the artist saw women as rapacious or threatening at this stage of his life. In this painting the clasped hands and physical closeness suggest a couple absorbed in love. Although Leighton sold the painting soon after completing it, for some reason he withheld it from exhibition until 1866, perhaps because his own shyness and isolation made him feel that he had put too much of himself into it for public display

Another example of the gentle and touching scenes in which young people express feelings of love for one another while engaging in some delightful shared activity is *Golden Hours* (plate 29). It shows a handsome youth of Italianate appearance playing a harpsichord, while a girl wearing a silk dress of flowered pattern watches with rapt attention. The mood was inspired by Venetian art of the early sixteenth century; Giorgione and others had invented a type of painting which treated the theme of romantic love with decorum and elegance through the metaphor of music-making. The association of music with amorousness had been further explored by Dutch seventeenth-century painters, and Vermeer's *Lady and Gentleman at the Virginals* (Royal Collection) has been cited as a source for *Golden Hours*. A reviewer wrote that 'Mr. Leighton has thrown such an atmosphere of music over his picture, that it "vibrates in the memory" like Shelley's stanzas'.

Golden Hours derives from Leighton's love of balance and symmetry, and the effects which make the arrangement harmonious and satisfying are most subtle. The figures are enclosed within a gilded niche, and the artist approaches them so closely that only their heads and upper bodies are fitted into the composition. Each figure occupies half of the picture space; the corner of the harpsichord marks the vertical centre of the painting, where the girl's sleeve overlaps his. However, whereas the volumes of the musician and the girl are approximately equal, in other respects the figures are contrasted: she is dressed in creamy white, and faces away from the spectator; he wears a green-black garment, and his entire face is shown; furthermore, Leighton has carefully graded the intensity of light across the curved surface of the niche so that she is brilliantly lit against a dark background, while he is seen in dramatic outline against shimmering gold. For the first time in Leighton's oeuvre an empty space occupies the centre of the composition, and yet the sense in which the whole revolves around a single pivot is as strong as ever. Leighton knew the power of caesura to lend emphasis to, or

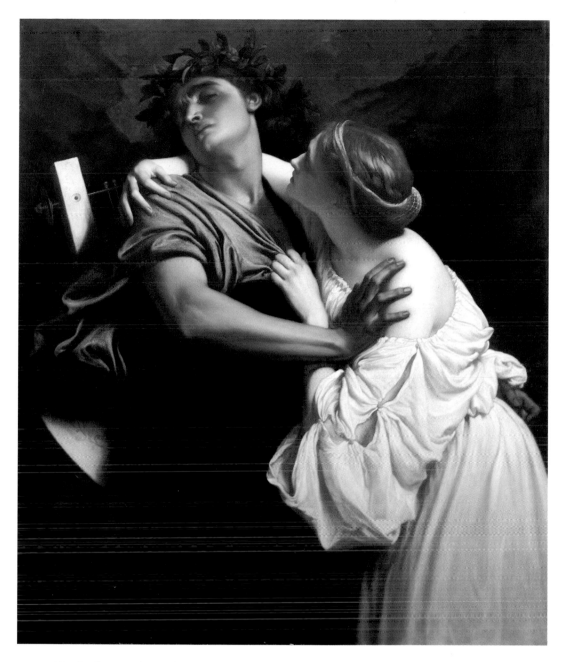

28. *Orpheus and Eurydice.* Exhibited 1864. Oil on canvas, 50 × 43 in. (127 × 109.2 cm.).
Leighton House, London

interrupt, a rhythm which might otherwise become monotonous. In *Golden Hours* the space between the two figures is as rich and beautiful as the textures and silhouettes of the figures themselves.

The painting was a popular and critical success. The Royal Academy could resist him no longer; in the summer of 1864 it was announced that he was elected an associate member. His self-esteem was hardly flattered by this; he knew that he was a better painter than many who had been elected ahead of him. He wrote to his friend F. G. Stephens, critic of the *Athenaeum*: 'As for the A.R.A. ship – I can't well (speaking *quite confidentially*) consider it a *great* honor now – but it has material advantages . . .' Thus with a certain degree of cynicism Leighton joined the ranks of the Victorian artistic establishment.

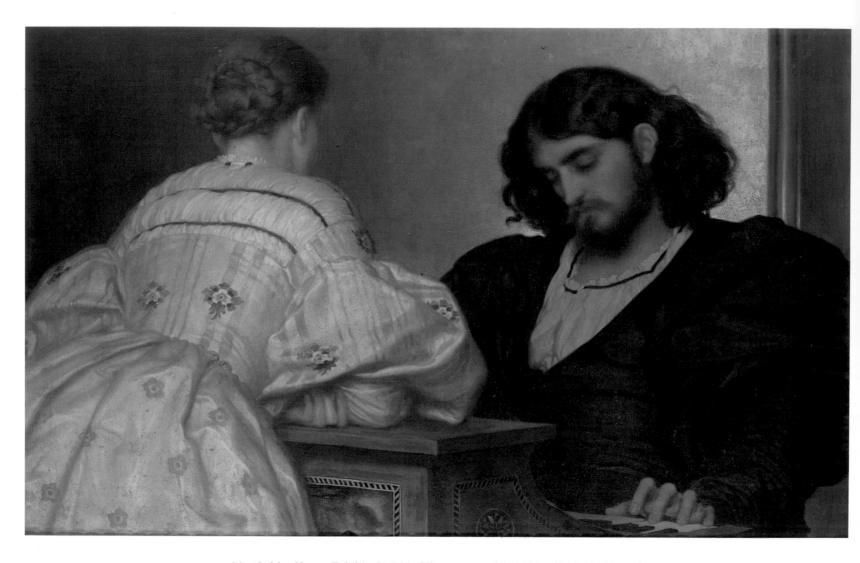

29. *Golden Hours.* Exhibited 1864. Oil on canvas, 36 × 48 in. (91.5 × 122 cm.).
Collection of Sir George and Lady Christie

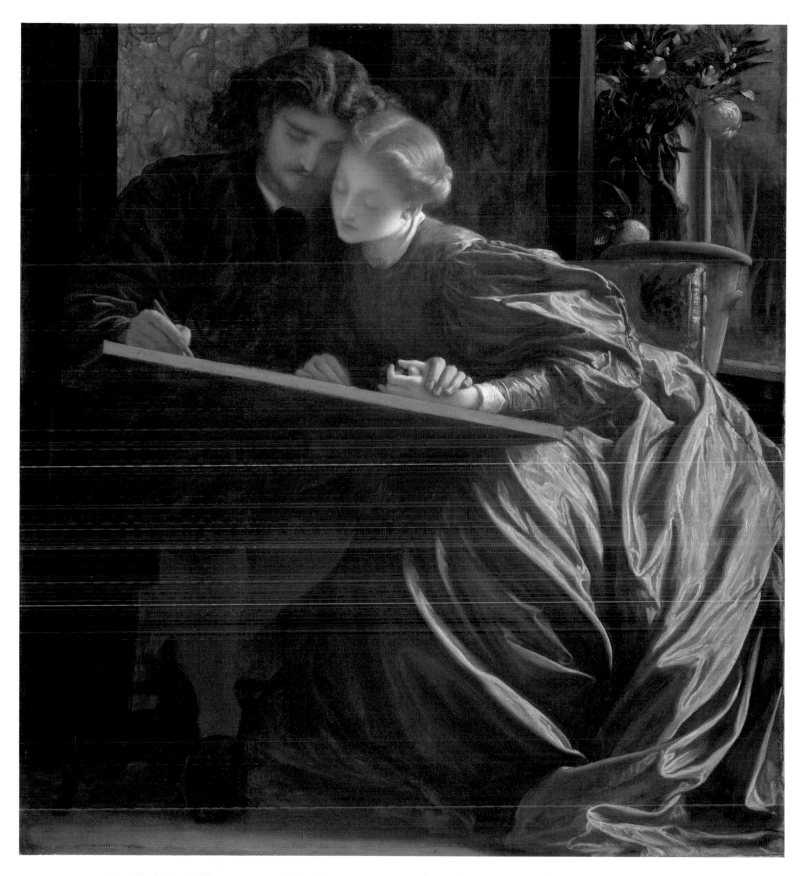

30. *The Painter's Honeymoon. c.* 1864. Oil on canvas, 33 × 30¹/₄ in. (83.8 × 76.8 cm.). Museum of Fine Arts, Boston

2

The Academician, 1864–1878

The Royal Academy's Summer Exhibitions of the 1860s were old fashioned in character and the works on display on the whole unimaginative. Many painters were perfectly content with a diet of portraiture and landscape, and reminiscences of the manners and customs of earlier times. A minority, and particularly those among the rising generation who understood the more sophisticated aesthetic theories which emanated from Europe, sought to depart from an art based on mere record-making and the repetition of familiar events from history and literature. As has been seen, Leighton stood apart from most of his contemporaries who were members of the Royal Academy, and met with distinct hostility from them. However, unlike Watts, Rossetti and Burne-Jones, he was determined to work from within rather than in opposition to the Academy.

Among the five pictures which Leighton showed at the Royal Academy in 1865, his first year as an associate member, was *Mother and Child* (*Cherries*) (plate 32). The attractions of works of this type were remarked by F. G. Stephens: 'Another picture, a very charming one indeed, illustrates what is the most popular side of Mr. Leighton's art . . . A young mother lies sidelong upon the floor of a room; her head is raised upon her elbow, and, in the hollow of her bent form, nestles a little child, her own, who playfully, daintily, and with exquisite childish grace, presses to her lips a full-blooded cherry.' There is a sentimental strain in Leighton's work, as in much Victorian art; both painters and writers felt a need to celebrate the joys of domesticity and family life in an age when premature death or ill-health might strike at any time. Leighton was, however, aware of the hazard of allowing paintings of women and children to sink into mere prettiness, writing on one occasion to a friend: 'By the by, if you think my picture pretty, please don't say so: it's the only form of abuse which I resent.'

Leighton has approached closely to the two figures in *Mother and Child* – the woman's sleeve and the hem of her skirt are cut off at the edges, and the white and pink of her flowing dress occupies the central part of the composition. The narrow band of foreground consists of an oriental carpet of ornate floral design; on the right in the background is a gilded and painted screen decorated with birds; the left-hand side is closed by a vase of white lilies. This was the stage in Leighton's career when he most positively delighted in detail and in a highly ornate pictorial surface, even to the extent of allowing painted patterns and textures to clash and conflict. Here the rich colours are reminiscent of Venetian art.

The following year Leighton exhibited a portrait, *Mrs James Guthrie* (plate 31), which depends upon the same kind of richly decorative painting. The accessories are accurately and meticulously depicted: the two vases contain specific varieties of roses and lilies; the chair on the right is of a recognizable ebony and mother-of-pearl type; the background is closed with a tapestry showing a mythological or pastoral scene. Again it is hard to imagine the artist conceiving this dark-toned and artificially lit painting without the example of

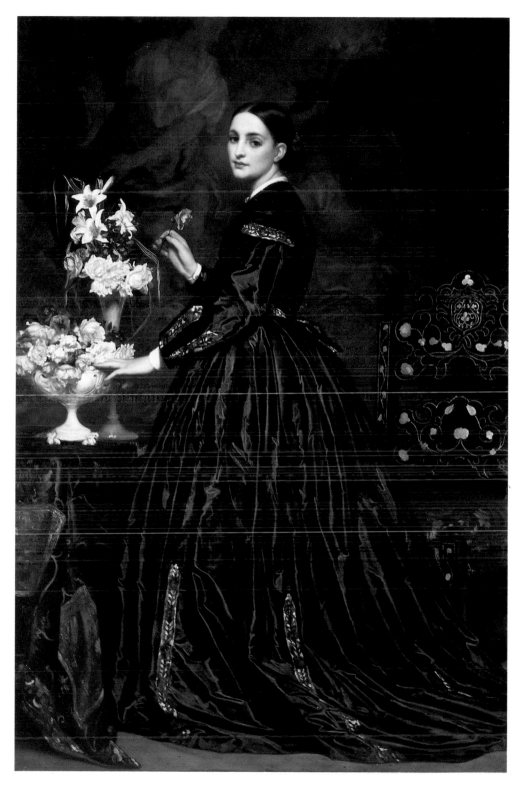

31. *Mrs James Guthrie.* Exhibited 1866. Oil on canvas, 82¹⁵/₁₆ × 54¹/₂ in. (210.7 × 138.5 cm.).
Yale Center for British Art, New Haven, Connecticut

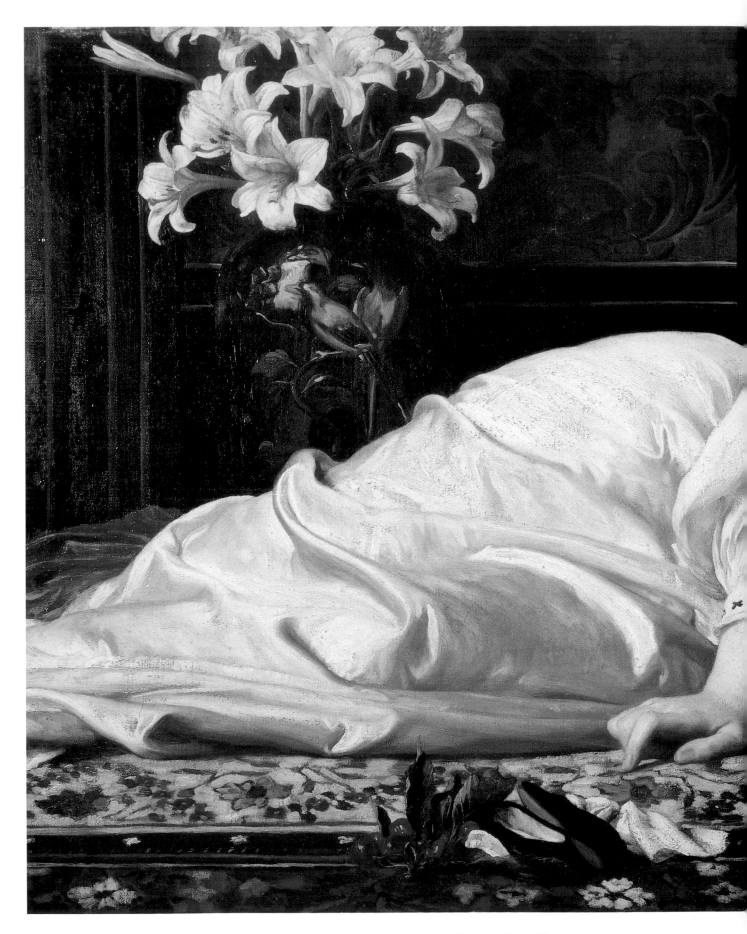

32. *Mother and Child (Cherries)*. Exhibited 1865. Oil on canvas, 19 × 32¹/₄ in. (48.2 × 82 cm.).
Blackburn Museum and Art Gallery

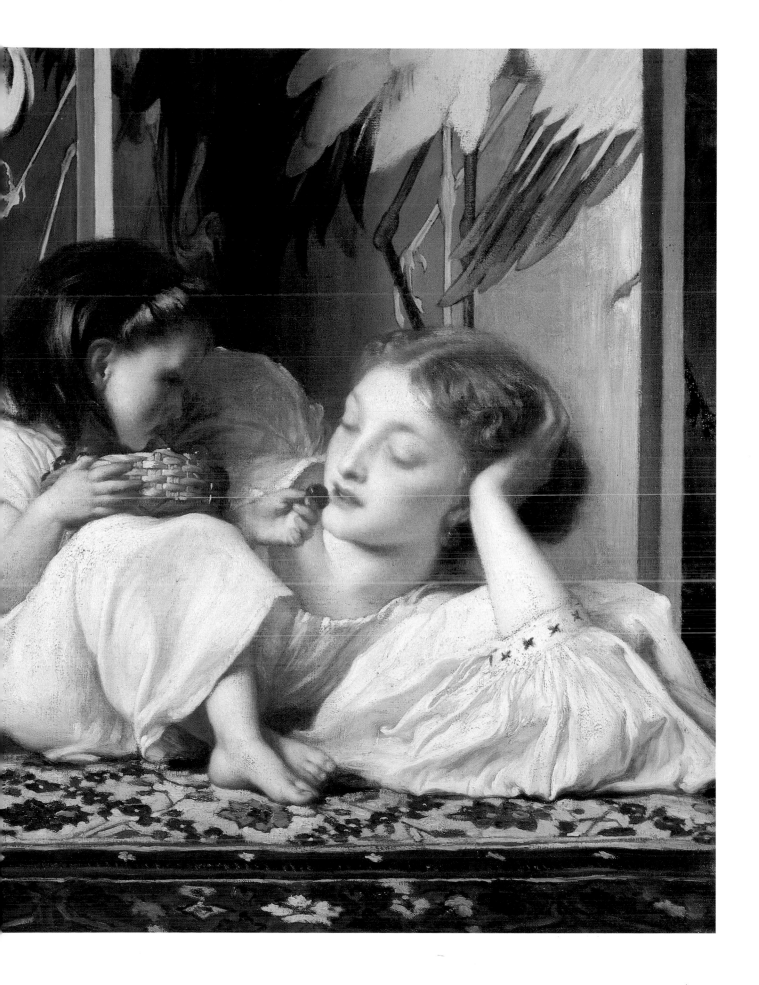

Venetian sixteenth-century portraiture, and in fact Leighton had spent the autumn of 1865 in Venice.

Leighton painted these pictorial furnishings with an enthusiasm and virtuosity unrivalled by any of his contemporaries; the skill with which he realistically described the appearance and texture of objects, pronounced even when he was very young, became his stock in trade in the 1860s. Realism, however, was not enough; painters of the Aesthetic Movement looked for ways in which they could draw together their compositions for the sake of a stronger feeling of ambience. Among the means at their disposal was the overall complexion of colour. In the case of his portrait of Mrs Guthrie, Leighton has reduced his range to sombre browns and blacks, carefully balanced across the composition. The subject's dress forms a glorious pyramid of black silk, interrupted by minimal embroidered decorations at the sleeve, shoulder and hem. On either side of her are patches of red-brown, in the cloth which drapes the table on the left and in the seat cover on the right. The background is largely painted from the same warm but subdued palette.

The purpose of this deliberate manipulation of lighting and colour was to emphasize the fragile beauty of the model. Her pale face appears at the centre of the painting, compositionally supported by the tones of the (predominantly white) flowers and the inlaid detail of the chair. Sittings for this portrait were repeatedly postponed because of Mrs Guthrie's poor health. Leighton has conveyed by the wan complexion and sequestered environment of his subject the tedium of an invalid existence.

The sensation of the 1866 Academy exhibition was Leighton's large painting *The Syracusan Bride leading Wild Animals in Procession to the Temple of Diana* (frontispiece). The artist's friend F. G. Stephens, who was already adopting the role of chief advocate of Leighton's work, wrote in the *Athenaeum*: '[The painting] lights the gallery with its brilliancy, exalts the taste of the year by its elegance, its coarseness by its refinement . . .' The work may have appeared exceptional, even aberrant, in the context of the Royal Academy of the 1860s, but it was for Leighton the fulfilment of his shift towards neo-classicism, of both form and subject. Leighton saw his stylistic development as a logical progression, writing: 'I can only speak of what is not a change but virtually a growth – the passage from Gothicism to Classicism (for want of better words) i.e. a growth from multiplicity to simplicity.' By simplicity Leighton meant a single and coherent scheme of organization, regardless of the physical size of the painting or the number of figures represented. He was to recall in 1873 how he had turned to classical subjects: 'By degrees, my growing love for form made me intolerant of the restraints and exigencies of costume and led me more and more, and finally, to a class of subjects, or more accurately to a state of conditions, in which supreme scope is left to pure artistic qualities . . . in which every form is made obedient to the conception of the design [the artist] has in hand. These conditions classic subjects afford. . .'

The Syracusan Bride shows twenty-seven figures, as well as numerous lions, tigers and leopards, all within a closely organized symmetrical arrangement. The central figure is framed by an open space, a caesura of sky and distant mountainside which is contrasted with the dense background of cypresses and stone-pines, Doric columns and sculpture, across the rest of the painting. The lateral parts of the composition are balanced in their shapes and masses. However, as in Leighton's earlier large-scale works, such as *Cimabue's Madonna* and *The Wise and Foolish Virgins*, compositional symmetry is combined with psychological progression. A change of mood operates across the width of the picture: at the head of the procession the figures are reverential, the colours of their draperies sombre and modest; the bride herself is attentive but self-possessed; the figures that follow are in festive mood and play happily with the animals.

If *The Syracusan Bride* followed a formula which had been utilized on previous occasions, the treatment of the figures represented a departure. Leighton had become a fanatical admirer of Greek art, and took every opportunity to study antique statuary. He familiarized himself with the forms of the Parthenon sculptures and other Greek works of art in the British Museum, and in his painting the figures are allowed greater space so that their more elegant and classically correct forms could be appreciated. Equally, the processional format is more specifically classical: no concession is made to picturesque perspective – the figures stand within a single, shallow pictorial space as they would in a sculpted bas-relief; further figures are placed below the platform across which the column proceeds, a device which softens the overwhelming horizontality of the composition. By raising the procession up on a plinth and causing the spectator to look upwards at the figures, a monumental quality is achieved.

Leighton's earlier paintings which took their subjects from ancient literature, such as *The Triumph of Music* and *Orpheus and Eurydice*, record relatively familiar events from mythology, and with clear moral implications. With *The Syracusan Bride* he chose a much more obscure subject, suggested by a brief reference in the second *Idyll* of Theocritus to the custom whereby girls who were to be married in the ancient kingdom of Syracuse first made devotions to the goddess Diana. The procession is led by a priestess, who implores the goddess to look favourably on the bride; attendants follow holding sacred vessels; and a group of young women carry flowers and fruit. The bride herself leads a lioness who wears a garland of flowers. Behind her come the women who lead the wild animals to the temple.

The subject was for all intents and purposes an invented one – the meaning would not have been clear even to a classical scholar – and it is in fact almost unimportant. The two lines from Theocritus were simply a pretext for Leighton to reconstruct the appearance of the ancient world as he imagined it to have been. The painting's decorative function, its expression of Leighton's vision of an elegant and graceful people, and its intrinsic harmony of colour and arrangement, were the artist's main preoccupations, and it is in this sense that the work may be regarded as essentially neo-classical, a conscious and deliberate revival of classical forms.

An attitude of mind which favoured classical themes in poetry and painting was beginning to prevail in Victorian England. Mythology provided an opportunity for artists to treat sexual themes, the moral implications of which would not be acceptable under any other guise. Those who enjoyed nude subjects could do so with impunity if the figures were seen to represent a subject from ancient legend. Walter Pater's essay on the German aesthetician Winckelmann, published in 1867, proved an inspiration to all those who believed that English art might aspire to the condition of Aesthetic Hellenism.

In 1867 Leighton seemed to issue a challenge to those who doubted the propriety of the type of neo-classical painting which he was instigating. His *Venus disrobing for the Bath* (plate 33) shows a female nude standing within an open portico of fluted Doric columns. The salacious quality of the painting may have been deliberate: the woman's body is displayed, not in a spirit of pride in her undressed beauty, but rather at a moment when she seems caught unawares, defenceless against the invasion of her privacy. The contorted pose is loosely derived from Leonardo's *Leda*, but the painting fails where so many of Leighton's previous works had succeeded, in the area of naturalism and straightforward painting skill. There is a fatal uncertainty about the articulation of the joints; Venus' right shoulder seems inaccurately drawn, and the twist of the body from the raised left hip to the upstretched right arm has led to a confusion about the muscles and folds of the stomach. Leighton had not yet gained technical command of the female nude, which is perhaps why he

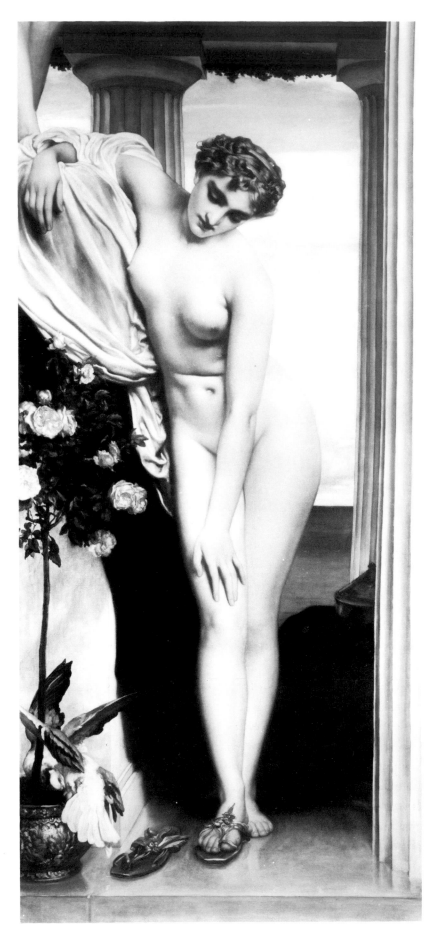

33. *Venus disrobing for the Bath*. Exhibited 1867. Oil on canvas, 79 × 35 in. (200.6 × 89 cm.). Private collection

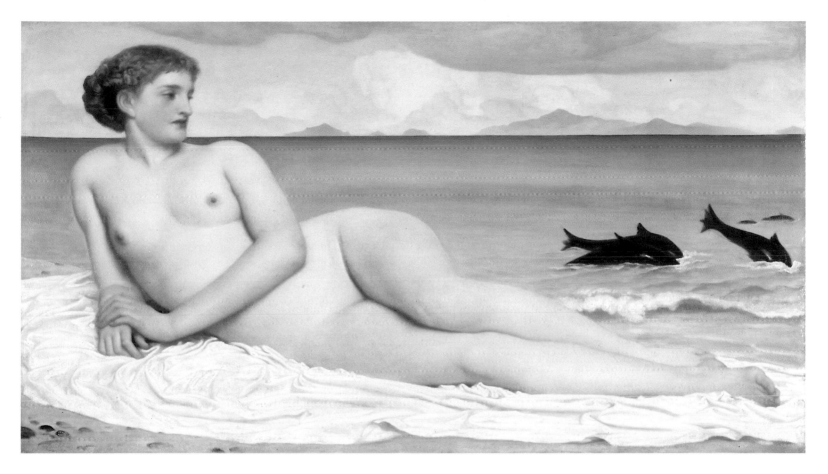

34. *Actaea, the Nymph of the Shore.* Exhibited 1868. Oil on canvas, 22¹/₂ × 40¹/₄ in. (57.2 × 102.3 cm.).
National Gallery of Canada, Ottawa

generally preferred to mask the forms of his models with draperies.

Nude subjects had not appeared at the Royal Academy for a number of years but *Venus disrobing* was accepted as a legitimate subject – an instance of the licence which was allowed painters of mythological subjects – the *Art Journal* going so far as to call it 'eminently chaste'. The painting was defended in the *Athenaeum* on the grounds that 'Nakedness is not the leading characteristic of this figure; that sense must be dull indeed, and very coarse withal, which can regard its noble *morbidezza* and exquisite form and colour with such eyes as commonly greeted the very popular, but thoroughly impudent, "Tinted Venus" of Mr. Gibson.' Leighton's contribution to English art was recognized: 'It is hardly needful to say that here is Art of a far higher than the homely or humorous sort, which obtains so commonly with us; something requiring ability beyond the painting of draperies with tact and skill.'

In the summer of 1867 Leighton travelled to Greece. The visit made a profound impression on him. The stylistic influence of ancient works of art which he could now study at first hand, and the impact of the very landscape which he recognized as the setting of historical and mythological events, were vital to his artistic development. He felt that he now understood the true spirit of classical art, which he believed had existed in its

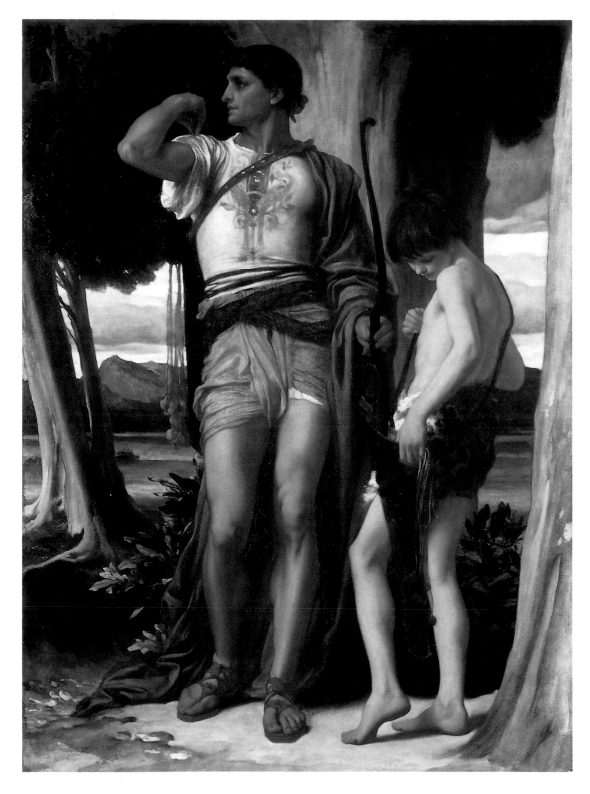

35. *Jonathan's Token to David.* Exhibited 1868. Oil on canvas, 67^1/$_2$ × 49 in. (171.5 × 124.5 cm.).
The Minneapolis Institute of Arts (John R. Van Derlip Fund)

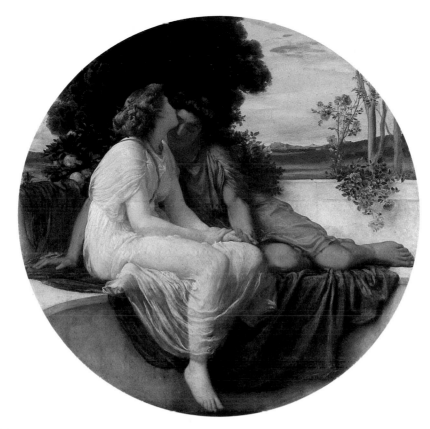

36. *Acme and Septimius*. Exhibited 1868. Oil on canvas, diameter: 37 in. (94 cm.). Ashmolean Museum, Oxford

purest form in Greek sculpture and architecture of the fifth century BC. He reacted against the Renaissance works of art which had previously entranced him, writing from Venice on his homeward journey: 'My first impression of the Gallery [the Accademia], coming as I did straight from the Parthenon, was that everything but the very *finest* pictures was wanting in dignity and beauty, and was *artificial*.' Hellenic art struck him as having a more noble and refined quality, and as being more natural and true, than anything that followed.

Among Leighton's exhibits of 1868 was *Actaea, the Nymph of the Shore* (plate 34), which shows one of the Nereids, the mythic guardians of the sea who controlled the waves and watched over sea-travellers. On this second occasion of his attempting a nude subject he still failed to resolve an anatomical weakness: the nymph's chest and arms hardly seem to belong to the same body as her hips and legs.

Leighton was trying very hard to raise his art into the realm of true and conscious classicism, and was keen to demonstrate his knowledge of, and debt to, both ancient and modern art. By undertaking nude subjects he was deliberately associating himself with a noble tradition of classical painting, which stretched back to the Renaissance, and which was currently enjoying a revival at the hands of a neo-classical school of painters in France which included Bouguereau, Cabanel and the Flandrins.

Despite the naturalism of texture and the learned and deliberate adoption of a classical pose for the figure, *Actaea* is without warmth and no sense is given of the artist having enjoyed painting this work. Algernon Charles Swinburne, who compiled an essay of notes on the Academy exhibition of 1868, was largely critical of Leighton's contribution. Of *Actaea* he wrote: '[the painting] has the charm that a well-trained draughtsman can give to a naked fair figure; this charm it has, and no other.'

37. *View in Spain.* 1866? Oil on canvas, 8 × 16 in. (20.3 × 40.6 cm.). Tate Gallery, London

The subject of *Jonathan's Token to David* (plate 35) was suggested by the event described in chapter 20 of the First Book of Samuel in the Old Testament. Jonathan is shown preparing to shoot three arrows, which were to be retrieved by the servant-boy standing beside him. According to their plan David, who is hiding in the landscape nearby, will gather from Jonathan's word of command to the boy whether it is safe for him to come out of hiding, or whether King Saul is still searching for him and his life therefore imperilled. The subject refers obliquely to the mutual love and loyalty of the two Biblical figures.

Leighton had several classical prototypes in mind when composing this painting. The contrapposto of Michelangelo's *David* may have provided the model for Jonathan's stance, although Leighton has not resolved the question as to which leg the figure is resting his weight on. The tilt of the shoulders is similar to that of *David* and both figures raise an arm to the shoulder. Certainly the scale of Jonathan, who occupies the entire height of the composition and thus seems to tower over the spectator, may be described as Michelangelesque. The posture may also owe a debt to the antique; the relaxed pose is similar to that of various Greek sculptures of Apollo, and the hand raised to draw an arrow may have been transposed from antique statues of Diana. Leighton had absorbed so much from his study of ancient works of art that he had gained a general understanding of what made a satisfactory pose or detail; but because every figurative element was meticulously drawn from the living model, the instances of direct quotation in his paintings are few.

In the late 1860s when Leighton was preoccupied with the formal and aesthetic possibilities of painting figures, he avoided subjects which involved a potentially distracting emotional confrontation of characters. Subjectless themes, such as *Mother and Child*, or genre-type works loosely based on mythology, for example *Acme and Septimius* (plate 36), which illustrates lines by the Latin poet Catullus describing adolescent love-making, were easier to handle.

Leighton still felt that his vocation as an artist who would raise the standard of English painting could be satisfied only if he undertook serious subjects from ancient literature and the Bible. However, he rejected familiar texts and established iconographies, choosing instead passive scenes which anticipate the dramatic moments when events unfold, or even inventing entirely new subjects tangentially based on incidental textual references. This is a curious strategy for an artist with classical aspirations, for the great tradition of European

38. *On the Nile*. 1868. Oil on canvas, 10¹/₂ × 16¹/₄ in. (26.8 × 41.2 cm.). Fitzwilliam Museum, Cambridge

classical art has always had the heroic acts of man and god as its principal subject-matter; mere decoration could not inform or uplift as could representations of emotion and the clash of human and deistic wills. Leighton's paintings of the 1860s eminently satisfy the criteria of the Aesthetic Movement, that they should be rich in colour and pattern and refined and decorous in their observation of the human form, but they fall short of the complete requirements of classical art. Taken as a whole, his 1868 exhibits were curiously unsatisfactory; and his figurative classicism was showing signs of anaemic historicism because he was evading the function of pictorial drama which the classic tradition required of him.

Following the summer exhibition of 1868 Leighton was elected a full member of the Royal Academy; in reply to his friend F. G. Stephens he sent a laconic message: 'My dear Stephens – 1,000 thanks for your amiable letter of congratulations – I value the sympathy of my friends very much, – I won't paint worse for being an R. A. In haste. Yours always, Fred Leighton.'

There was another aspect of Leighton's painting, of which the Victorian public was largely unaware – the landscapes and studies of architecture which he made while travelling abroad each summer and autumn. John Gere has written of Leighton as 'a landscape artist *manqué*, diverted from his true bent by the official view of the role of the artist in society'. Leighton's pure landscapes, such as *View in Spain* (plate 37), which was probably done in 1866, and *On the Nile* (plate 38) of 1868, derive from his intense meditation on topography and atmosphere; their feeling for the physical mass and quality of light is highly personal. In Egypt Leighton wrote of what he saw: 'The keynote of this landscape is a soft, variant, fawn-coloured brown, than which nothing could take more gratefully the warm glow of the sunlight or the cool purple mystery of shadow . . . At this time of year the broad coffee-coloured sweep of the river is bordered on either side by a fillet of green of the most extraordinary vivacity, but redeemed from any hint of crudity by the golden light which inundates it.' Thus the painter's eye searched for the nuances of colour as well as the overall complexion of the landscape.

39. *View of a Ruined Arch*. Oil on canvas. Location unknown

Leighton was also interested in the structures of buildings, and the way in which light was cast over their forms or was reflected from their surfaces. His *View of a Ruined Arch* (plate 39), probably done in North Africa or Spain in the 1860s, reveals this fascination with the play of light and shadow over a three-dimensional form. *Study of Houses, Venice* (plate 41) shows a line of buildings seen beyond a wall and a tree; the view has been taken early in the morning, when the oblique rays of the sun cast long shadows across the foreground and throw radiant light upon the architecture and the tip of the cypress. He also made studies of interiors, such as *The Interior of St Mark's* (plate 40) where the rich patterns of golden mosaics gleam out of the darkness of the cave-like basilica.

Leighton's studies of landscape and buildings reveal his links with a European tradition of painting, as well as his remoteness from the mainstream of English landscape painting in the 1860s, which was principally concerned with the observation of detail. Through his friendship with the Italian landscape painter Costa, and later as a result of his study of Corot's *plein air* landscape style, he learnt to express natural forms and light effects in oil sketches which are vividly handled impressions of abstract forms rather than meticulous records of geographical data; the brevity and directness of these studies demonstrate his dexterity and feel for the quality of paint. Leighton's landscape painting was for his own satisfaction and to serve the education of his eye.

40. *The Interior of St Mark's. c.* 1864. Oil on canvas, 11³/₄ × 18¹/₂ in. (29.9 × 47 cm.).
Collection of Edmund J. and Suzanne McCormick

The conscious desire on Leighton's part to convey the spirit of ancient Greek art, as perceived by a Victorian audience, and to place his subjects in authentic settings, led to his adopting what some considered an even more remote and inaccessible style of art. *Daedalus and Icarus* (plate 44) shows the moment in the legend as recorded by Ovid when Icarus, equipped with wings made of feathers and wax by his father Daedalus, prepares to fly. As with *Jonathan's Token to David* the scene represented does not in itself inform the spectator of the event's significance, but merely anticipates the conclusion. Icarus ignored his father's earnest advice not to go too high, as a result he fell to his death when the wax melted in the warmth of the sun. The subject provided an opportunity for Leighton to display his command of the male nude figure. Icarus' body is seen at a more comfortable range and is more ably managed than Jonathan's; the distribution of weight is more logical; and the action of stretching up to reach the wing less disturbing of the equilibrium of the composition. The torso and head, and particularly the raised arm and clenched fist, suggest the poses of the statues of *Castor* and *Pollux* in the Piazza del Quirinale in Rome. Another likely source is the *Apollo Belvedere* in the Vatican, and Canova's statue of *Icarus* (Venice, Museo Correr) was perhaps also in Leighton's mind.

In his middle career Leighton treated the male nude with greater conviction than the female, and his mythological and Biblical subjects with nude or partially draped male figures are generally successful. Sometimes he painted and drew nude subjects in classical settings but without specific subjects; an example is his *Boy with a Shield holding a Vase* (Truro, Royal Institution of Cornwall), for which he made a compositional design showing the naked figure standing before the Doric columns of a Greek temple (plate 45). To the

41. *Study of Houses, Venice.* Oil on canvas, 9¹/₂ × 15¹/₂ in. (24.1 × 39.3 cm.). Collection of Mr and Mrs John Gere

42. Colour sketch for *Helios and Rhodos. c.* 1868. Oil on canvas, 8¹/₄ × 5¹/₂ in. (21 × 14 cm.).
Collection of Benedict Read

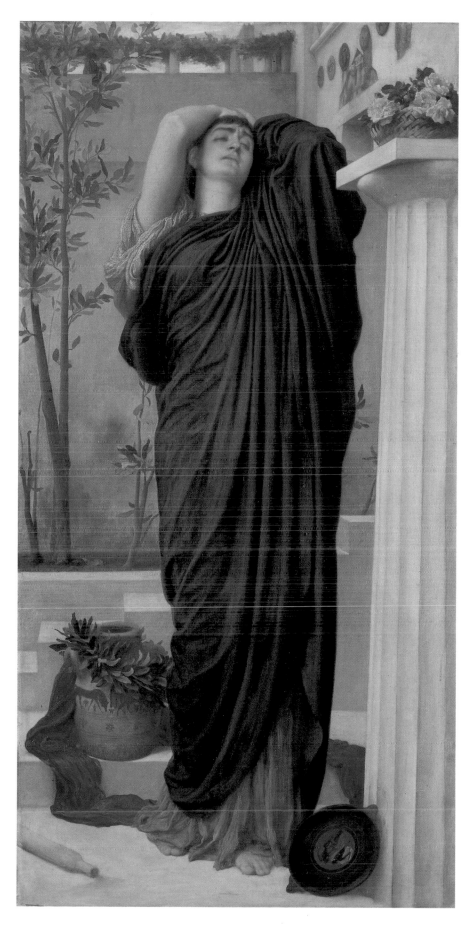

43. *Electra at the Tomb of Agamemnon*. Exhibited 1869. Oil on canvas, 58¹/₂ × 29 in. (148.6 × 73.6 cm.).
Ferens Art Gallery: Hull City Museums and Art Galleries

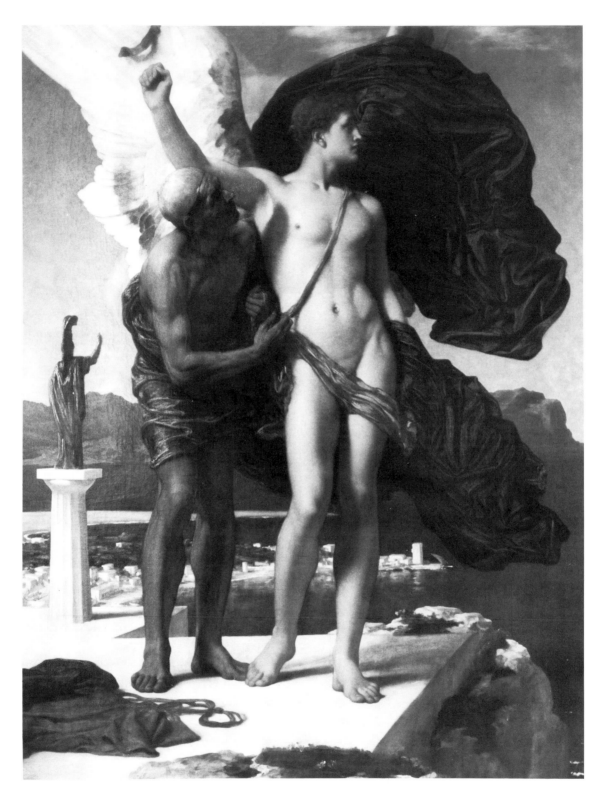

44. *Daedalus and Icarus.* Exhibited 1868. Oil on canvas, 54³/₄ × 41⁷/₈ in. (138.2 × 106.5 cm.).
Faringdon Collection Trust

45. Drawing for *Boy with a Shield holding a Vase. c.* 1869. Location unknown

Victorian way of thinking nudity was permissible when associated with the South, or with antiquity; Ruskin wrote that in Hellenic art 'the nude comes to be regarded in a way more grand and pure, as necessarily awakening no ideas of the base kind (as pre-eminently with the Greeks).' Other writers, Swinburne among them, revelled in the eroticism of Greek legend and the opportunity to admire naked flesh in its artistic representation. Hellenism came to be perceived as a means of indulging a salacious delight in nudity, and was particularly associated with male homosexuality.

Costa congratulated Leighton on the 'courageous purity [of] his undraped figures; . . . there is . . . no remote hint of *double entendre* veiled by aesthetic refinement, any more than there is in the Bible, the Iliad, or the sculptures of Pheidias.' The word 'nobility' was used by critics to describe what they held to be Leighton's high-minded indifference to the physical attractions of his models. Of *Greek Girls picking up Pebbles by the Sea* (see plate 48), shown at the Royal Academy in 1871, a reviewer wrote: 'This is precisely a subject fitted to show the nobility of the artist's power. Hardly anyone but he would avoid at least a suspicion of a desire to hint, however delicately — let us put the finest point which is available on the subject — at the personal charms of the girls, who are thus beset by the breezes of the sea, and wandering, in all the freedom of their gracefulness, by the shore at morning.' Disraeli, who was more cynical about the mechanism by which an artist drew an audience to his paintings, described in his novel *Lothair* (1870) how a character closely modelled on Leighton

69

46. *Hercules wrestling with Death for the Body of Alcestis.* Exhibited 1871. Oil on canvas, 52½ × 104 in. (133.4 × 264.2 cm.).
Wadsworth Atheneum, Hartford. The Ella Gallup Sumner and Mary Catlin Sumner Collection

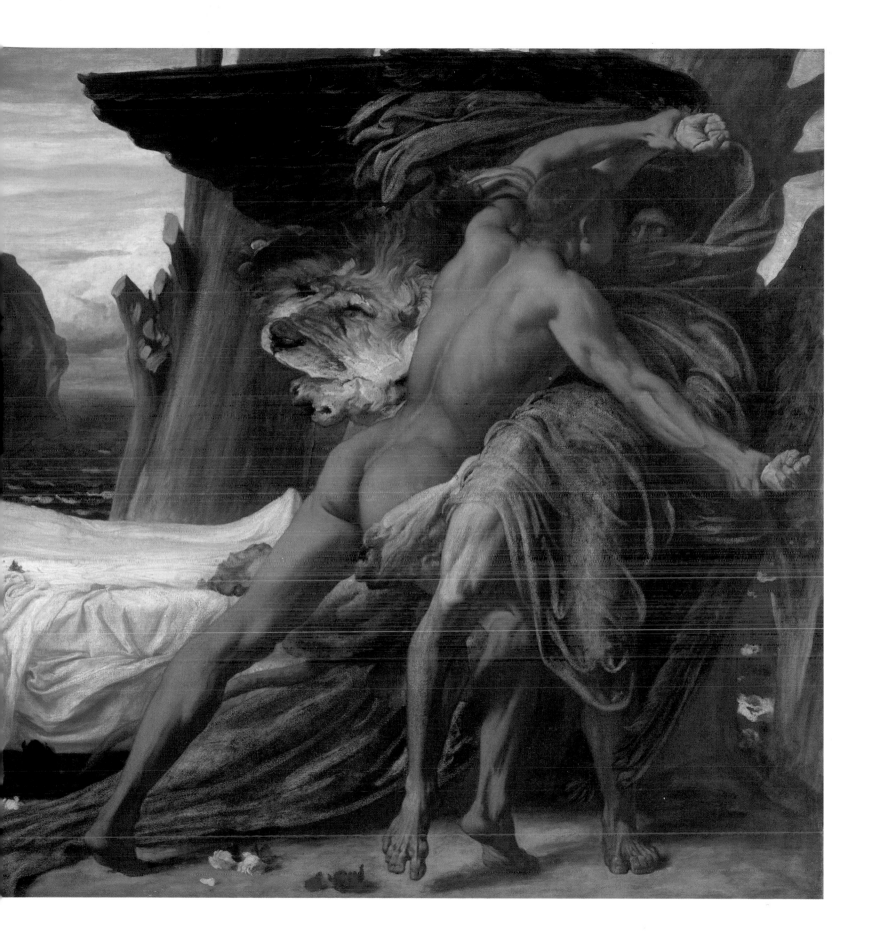

called Mr Phoebus (and the choice of the Greek word for the sun for the name of this fictional artist is surely significant) displayed to his friends 'a figure of life-like size, exhibiting in undisguised completeness the perfection of the female form, and yet the painter had so skilfully availed himself of the shadowy and mystic hour and of some gauze-like drapery, which veiled without concealing his design, that the chastest eye might gaze on his heroine with impunity.'

Daedalus and Icarus, and another of Leighton's 1869 Academy exhibits, *Helios and Rhodos* (destroyed; for the colour sketch for the painting see plate 42), reveal the painter's new passion for a landscape bathed in sunlight. The background of coastline and mountain ranges, which Leighton painted on the basis of sketches made on the island of Rhodes in 1867, is rich in the brilliant colour and pellucid atmosphere which had so impressed him on his travels in the South: purple and mauve horizons are set against azure skies and rise above cerulean seas. His enthusiasm for the Mediterranean was more than just a personal response to the effects of light and atmosphere. He was increasingly drawn to the idea of the sun not only as a fundamental and universal force, in the sense that the natural world depends upon the sun's energy, but also as a source of spiritual inspiration. In an age when scientific theory had undermined the basis of conventional faith, Leighton saw the sun's energizing force as something godlike. From this stage in his career he was fascinated by legends which invoked the sun: Icarus meets his fate because he proudly ignores the greater power of the sun. Similarly, Helios was the Greek divinity of the sun; his embrace with the nymph Rhodos led to the birth of the island of Rhodes.

Electra at the Tomb of Agamemnon (plate 43) shows the heroine of Greek tragedy standing before the tomb of her father Agamemnon, King of Argos, who had been treacherously murdered by Electra's mother Clytemnestra. Electra swears to avenge her father's death and to recover the throne of Argos for its rightful heir, her brother Orestes.

Once again Leighton has drawn physically close to the protagonist, so that her gestures and expressions may be closely observed. From the outset of Leighton's professional career there had been those who felt that he was not good at the representation of emotion. *Electra* was perhaps a deliberate attempt to refute such charges, and the painting stands in stark contrast to the passivity of most of his subjects of the late 1860s. However, Leighton's representation of human passion remains stylized and dependent upon classical drama; Electra's gesture – the raised arms clasped about her head – is a ritualized expression of despair.

Leighton's 1869 showing at the Academy was well received; the *Athenaeum* considered his 'force to be as noteworthy as ever, with an accession of severity in style which was at times ere now lacking to him.' The *Art Journal*, writing specifically about *Daedalus and Icarus*, applauded a type of painting 'which may be likened to a Greek cameo; indeed the style is almost more plastic than pictorial; the outline is sharply cut in marble, the surface is smooth as a highly-finished bas-relief. The manner may be pushed a little far; yet pictures of this poetic thought, classic beauty, and ideal treatment, are but too rare in our English school.'

Two remarkable paintings exhibited in 1871, *Hercules wrestling with Death for the Body of Alcestis* (plate 46) and *Greek Girls picking up Pebbles by the Sea* (plate 48), may be seen as representing two aspects of Leighton's art in its middle phase. Both served the Victorian cult of Hellenism, but in other respects the two are at opposite poles. *Hercules wrestling with Death* takes its subject from Greek mythology: Hercules fights and vanquishes Thanatos, the winged messenger of death, and thus saves Alcestis who had offered her life in place of her husband's. The sacrifice and resurrection of Alcestis were described in poems by Robert Browning and

47. Studies for *Hercules wrestling with Death for the Body of Alcestis* and *Captive Andromache*.
Black and white chalk on blue paper, 8¹/₂ × 11¹/₂ in. (21.6 × 29.2 cm.). Leighton House, London

William Morris, both loosely based on Euripides' tragedy *Alcestis*, and it was perhaps these texts which Leighton had in mind when he conceived the subject.

The work is the consummation of Leighton's adaptation of stagecraft to the purpose of picture-making, and is one of the most elaborate and carefully constructed works of his career. As usual the first idea of the composition was laid out in postage-stamp size studies in which only the main elements can be seen (see plate 47). Nevertheless the finished painting corresponds to the study: the mourners on the left are balanced by the figures of Hercules and Thanatos, locked in combat at the right. The two groups are connected by an open U-shaped curve which sweeps across the width of the composition through the draperies and legs of Hercules and Thanatos to the two girls in the left foreground and up into the huddled men, women and children. Certain compositional elements, the underside of Thanatos' wing and the line of the background tree, support a

returning arc across the upper part of the painting. There is just one interruption to this enclosed arrangement – the central view out towards the sea and the sky. This loose but deliberately contrived ellipse consists entirely of sombre colours: the reds, mauves, greys and blues of the mourners' draperies; the brick-coloured flesh of Hercules' nude body; and the green-blue draperies and grey flesh of Thanatos. Across the centre lies the body of Alcestis, draped in shimmering white and strewn with flowers. Leighton has distinguished in both compositional and colouristic terms between the living figures – the struggling Hercules and Thanatos, and the mourners who ripple with anxiety – and the static and serene corpse of Alcestis.

Greek Girls picking up Pebbles by the Sea serves a different aesthetic purpose, and its subject requires no elucidation. This is a decorative scheme in which the standing and bending figures provide an abstract rhythm of shapes and colours. The painting has no narrative content or didactic function: it is an exploration of what Leighton considered to be ideal beauty – the draped female form in a timeless landscape setting. Four women are shown; each is unrelated to the others in pose and scale; and there is no psychological communication between them. However, although each is conceived and studied separately, Leighton has carefully composed them into an overall pattern. The largest (or the one closest to the spectator if the artist's scheme of perspective is accepted) is balanced by the stooping figure on the left; the two subsidiary figures provide a linking counterbalance to the larger ones. Furthermore, the painting is a sumptuous arrangement of colour: each woman wears a loose-fitting dress of shades ranging from orange-red, through salmon-pink, to cream. Three have cloaks or shawls of different hues, one of them a rich blue-purple. The warm colours and cohesive draperies serve to draw together the elements of the composition; Leighton's instinct for the harmonious arrangement of shapes and colours within a pictorial space receives its complete expression in this work. He increasingly resisted the temptation to incorporate bravura passages, and concerned himself more with the overall impact of his paintings. The example of G. F. Watts, Leighton's longtime friend, perhaps encouraged him towards a larger and less indulgent artistic purpose.

Hercules wrestling with Death and *Greek Girls picking up Pebbles* offered alternative directions for Leighton to follow. The dichotomy was analysed by F. G. Stephens, who wrote of *Hercules wrestling with Death*: '[The work] displays exquisite taste, and a marvellously accomplished mind, but fails . . . to prove that the artist's powers were equal to the theme. . . . Of course this is anything but a sign of weakness on Mr. Leighton's part, being only, as it seems to us, a proof that his genius is not wisely employed on subjects which involve tremendous action or tragic expression.' But, Stephens went on: 'Never was Mr. Leighton happier in choosing a subject which, in itself, is nothing, but is charming in his hands, than in *Greek Girls picking up Pebbles by the Sea*: a delightful composition, comprising figures of almost exhaustless grace, and wealth of beauty in design and colour, besides what loveliness it shows in the stooping forms of the damsels, whose draperies a boisterous wind tosses without betraying.' As an exercise in subjectless painting *Greek Girls picking up Pebbles* was a seminal work of the Aesthetic Movement.

Leighton was himself well aware of the different artistic purposes that these two paintings served. Later on, in his first Address to the students of the Royal Academy, he stated: 'On one end of the scale there will be men vividly impressed with and moved by all the facts of life, and a powerful vitality will lend charm and light to their works; on the other we may expect to find men who are more strongly affected by those qualities in which Art is most akin to Music, and in their works the poetry of form and colour will be thrown as a lovely garment over abstract ideas or fabled events.'

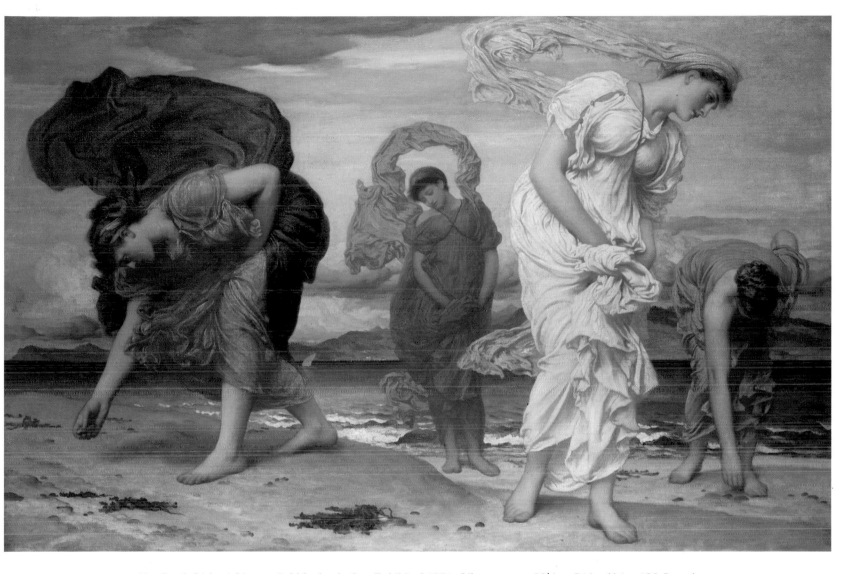

48. *Greek Girls picking up Pebbles by the Sea.* Exhibited 1871. Oil on canvas, $33^{1}/_{8} \times 51$ in. $(84 \times 129.5$ cm.$)$.
Owen Edgar Gallery, London

49. Compositional design for *The Arts of Industry as applied to War*. 1870–2.
Pencil and white chalk on brown paper, 15 × 35½ in. (39 × 90 cm.). Private collection

Leighton continued to look for opportunities to paint works for public display, the themes of which would interest and inform a wide audience. His rising prominence made him an obvious candidate to participate in the decoration of the interior of the South Court of the new South Kensington Museum, which had been under discussion since 1860. In 1863–4 Leighton contributed two oil cartoons representing the artists Nicola Pisano and Cimabue for mosaics (both in the Victoria and Albert Museum); and in 1868 he and Watts were officially commissioned to prepare designs for mosaic decorations in the semicircular lunettes which occupied the north and south ends of the South Court at gallery level.

At first Leighton considered how he might illustrate the theme of the arts in relation to civilization in one single painting – exploring the possibility of a scheme showing a fifteenth-century city in Italy, where artists, architects and craftsmen work together to secure the defences. Gradually the idea emerged of a pair of frescoed murals, both to be painted by Leighton, which would exploit the shape of the lunettes and in which the scale and symmetrical composition would be approximately matched. The first, *The Arts of Industry as applied to War* (compositional design, plate 49), shows the preparation for battle in a medieval and Italianate setting; the second, *The Arts of Industry as applied to Peace* (colour sketch, plate 51), reveals the benefits of concord – and for this scene Leighton turned to the civilization which he had come to value most highly, that of ancient Greece.

Leighton worked on designs for the two murals from 1869, but was interrupted by a severe attack of rheumatism in 1870. Numerous drawn studies for individual figures were made (see plate 50), but progress was extremely slow. Relations between Leighton and the museum officials worsened: he resented their attempts to cut corners, while they chivied him to devote more time to the project. Leighton had not been entirely happy with the terms originally offered, but had accepted them on the grounds that 'the promotion of mural painting of a high class is an object for which I am ready to make personal sacrifices'. In 1875 a new schedule was devised and provision made for assistants, but a dispute blew up between the Treasury, who were

50. Study for figures in *The Arts of Industry as applied to War*. Black and white chalks on blue paper, 8³/₄ × 11¹/₄ in. (22.2 × 29.8 cm.) Peter Nahum Gallery, London

paying for Leighton's work, and the South Kensington Museum: Leighton was accused of postponing 'public for private work' and devoting 'to the former only such leisure moments as may suit [his] convenience'. The museum justly responded: 'Mr. Leighton has always proved himself most punctilious in the fulfilment of his engagements.'

The Arts of Industry as applied to War, which was finally begun in 1878, contains a large crowd of figures, mostly standing on a wide flight of steps but also placed within an architectural framework of Gothic buildings. In the right foreground youths test cross-bows; in the left women embroider a standard; in the centre elegantly dressed young braves try on pieces of armour and compare their weapons; on the terrace in the background a banner is unfurled in readiness for battle.

The broad outline of the composition of *The Arts of Industry as applied to Peace*, commenced in 1883, follows that of *War*: a marble quay has replaced the flight of steps, and a curious half-circular atrium provides the principal setting for the figures (for a drawn study of this arrangement see plate 52); a hillside rises above the classical architecture and a distant view of temple buildings and palm trees is offered in the place of campaniles and cypresses. There are rather fewer figures in *Peace* than in *War*, and a compartmental arrangement is more rigorously followed. Undraped male figures, unloading merchandise in the lateral foregrounds, are separated from the central group of women and children, who adorn themselves with rich costumes.

The differences between the two murals indicate the artist's view of history: a medieval townscape provides the setting for men to prepare for battle, the thrusting shapes and sombre colours seeming to support the general mood of bellicosity. Conversely, classical architecture, with its sweeping lines and pleasant enclosures, lends itself to peaceful and indulgent activity; and lighter, brighter colours suggest the benefits of a golden age.

Leighton painted his South Kensington murals in Gambier-Parry's spirit fresco, which he had first used at Lyndhurst for *The Wise and Foolish Virgins*, but on this occasion the medium produced less satisfactory results. There were difficulties about getting a suitable surface to work on; eventually the lunette on which *War* was to be painted was prepared with white lead and gilder's whiting, but it remained so rough that it was,

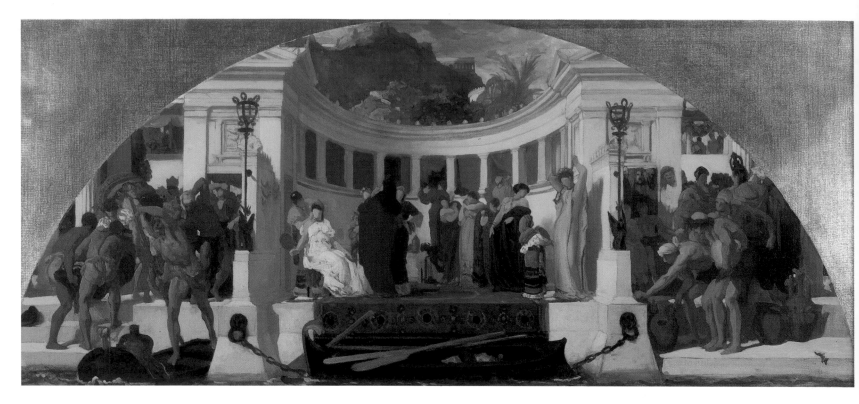

51. Colour sketch for *The Arts of Industry as applied to Peace. c.* 1872–3. Oil on canvas, 16 × 36 in. (40.7 × 91.4 cm.).
Victoria and Albert Museum, London

52. Study for *The Arts of Industry as applied to Peace.*
Black and white chalks on blue paper, 9 × 12¹/₂ in. (22.8 × 31.8 cm.). Leighton House, London

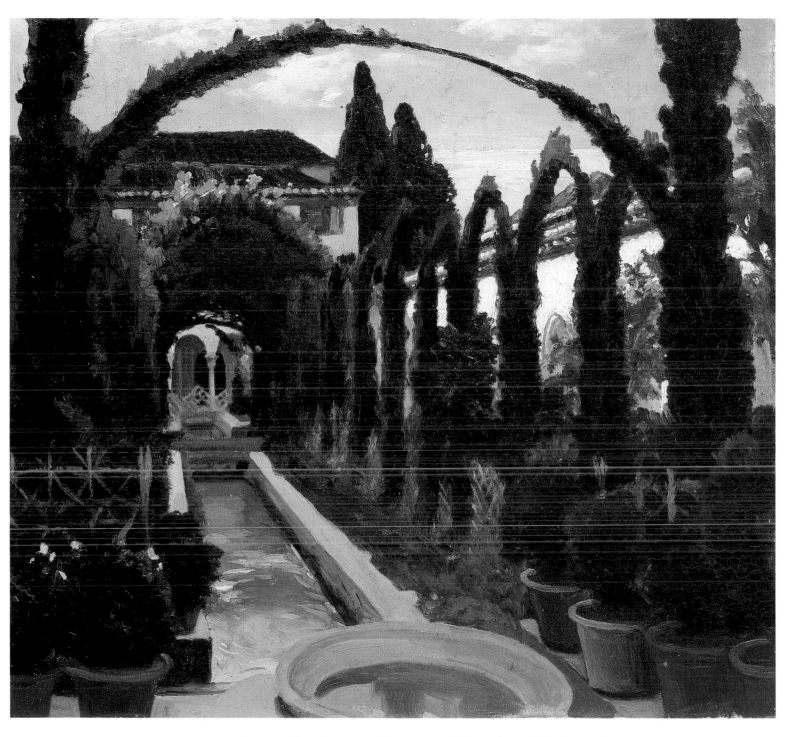

53. *Garden of Generalife*. Early 1870s. Oil on canvas, $10^1/_2 \times 11^1/_2$ in. (27 × 29 cm.).
Private collection

according to Leighton, 'like painting on a gravel walk'. Gambier-Parry told Thomas Armstrong that Leighton had failed to brush the colour into the ground, but had instead used the medium 'in much the same way as he would lay oil paint on a prepared canvas'.

Indebted though they are to Raphael's *Stanze*, particularly *The School of Athens*, and despite Leighton's attempt to provide uplifting themes, the murals are no more than decorative ensembles. The disappointment felt by many of Leighton's contemporaries is exemplified by Ford Madox Brown's comment on *War*: 'Why has not the President taken advantage of some such historical incident as "Michael Angelo fortifying Florence," instead of designing a pack of sleepy youths apparently trying on arms and costumes for a fancy dress ball?' It must be admitted that the murals of *The Arts of Industry* are stiff and grandiose, and utterly detached from the preoccupations and imaginations of Leighton's looked-for wider public. Spoilt by the darkening and disintegration of their materials, they are now impossible to see in their full scale or in the perspective which the artist envisaged.

In the 1870s Leighton may have believed that the advancement of his reputation depended on large-scale and seriously intentioned works. None the less his most popular works were the quite straightforward paintings, often without ostensible subject, which he painted on the basis of studies made during his frequent visits to the Mediterranean South. For these works he could count upon ready buyers and an enthusiastic reception. In its review of the 1871 Academy exhibition the *Art Journal* sensed a change of taste and described how 'a new, select, and also small school has been formed by a few choice spirits . . . [who] cherish in common, reverence for the antique, affection for modern Italy; they affect southern climes, costumes, sunshine, also a certain *dolce far niente* style, with a general Sybarite state of mind which rests in Art and aestheticism as the be-all and end-all of existence.' Although Leighton was not specifically referred to as a member of this group, his works were undoubtedly in the reviewer's mind.

The following year Leighton exhibited *After Vespers* (plate 54), a painting which typified the new easygoing and deliberately pleasing style. The painter has caught the moment when a young girl, rosary in hand, lifts her skirts clear of a dusty floor as she prepares to depart from church. The painting only pretends to be a snapshot of modern life. Leighton was far too concerned with the meticulous preparation of his works — on this occasion he utilized the studies he had made of the basilica of St Mark's in Venice (see plate 40) to provide the mosaic-covered niche before which his model stands. Even so, he has attempted to instil a feeling that the painting records a passing moment of daily life.

Leighton was applauded for the greater naturalism of his easel paintings of the early 1870s, but in his abandonment of specific subjects in favour of genre he ran the risk of allowing his pictures to become merely coy. A class of figurative painting emerged in the middle years of Leighton's career which were the result of a deliberate attempt on his part to court popularity at a time when there was a new taste for sweetness and charm in art.

Far superior were the paintings in which Leighton showed women and children in domestic surroundings, unconscious of the presence of the artist. Two examples were shown at the Royal Academy in 1874: *Moorish Garden: a Dream of Granada* and *Old Damascus: Jews' Quarter*. The first of these was based upon a fresh and immediate study of a garden at Generalife in Spain (plate 53). A channel of water, which ripples invitingly in the sultry atmosphere, is confined by orange bushes in pots, cypresses, and a pergola of trained

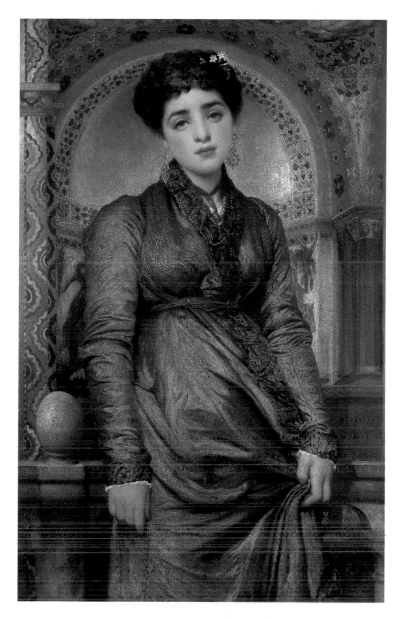

54. *After Vespers*. Exhibited 1872. Oil on canvas, 43 × 27¹/₂ in. (109.2 × 69.9 cm.).
The Art Museum, Princeton University, New Jersey

shrubs. Leighton delighted in settings which were enclosed and secluded, into which no element of the modern world might penetrate. In the finished painting he introduced a young girl, barefooted but swathed in richly patterned draperies, who offers drops of water to a pair of peafowls. Leighton here goes beyond mere informa-tion-giving: he evokes the sensations offered by a certain place, whether real or invented, so that the spectator can savour its particular character.

Old Damascus: Jews' Quarter (plate 55) originated as a sketch or study done during Leighton's first visit to Syria and the Holy Land in 1872–3. The alternative title, 'Gathering Citrons', describes the scene: a young woman is seen knocking fruit from the branches of a lemon-tree which grows within the courtyard of a richly decorated house; a child holds out her dress to catch the falling fruit; while an older woman momentarily inter-rupts her gardening to see whether the task is successfully undertaken. The scene is touchingly simple and

55. *Old Damascus: Jews' Quarter. c.*1873–4. Oil on canvas, 51 × 41 in. (129.5 × 104.1 cm.). Private collection

56. *Mrs Henry Evans Gordon*. 1875. Oil on canvas, 36 × 37 in. (91.5 × 94 cm.). Leighton House, London

utterly delightful, an opportunity for decorative but naturalistic genre rather than a dutiful account of an event in exotic surroundings.

Leighton was congratulated for these two paintings. A painter friend compared his mythological *Clytemnestra* (London, Leighton House) and his Hellenic *Antique Juggling Girl* (untraced) with *Old Damascus* and *Moorish Garden*: 'From those to turn to these, seems like leaving a garden fragrant with roses and citron blossoms, where I hear the murmur of cooling streams . . . to enter a museum filled with dusty plaster casts.' Leighton still believed in the hierarchy of types of subjects, and in the relative importance which academic convention accorded to each. Because of this he doubted whether his time was usefully spent on works which were neither instructive nor elevating, but merely delightful.

He had similar reservations about portraiture, and was determined not to allow importunate clients to distract him from the kind of painting which he believed most worthwhile. On one occasion he refused a portrait commission, writing: 'What little leisure I have for portraits (which I own to painting unwillingly) is already given away and I have had to refuse even old friends.' The majority of Leighton's successful portraits were of people he knew well, although he seldom departed from portrait conventions or indicated feelings of affection for the sitter. In 1875 he exhibited his second portrait of May Sartoris, who was by then married to Henry Evans Gordon (plate 56). The forthright and self-confident air of the sixteen-year-old has given way to that of a soulful and highly strung woman who seems to avoid psychological confrontation with the portraitist.

Leighton's portrait of the explorer, sometime diplomat, and man of letters, *Captain Sir Richard Burton* (plate 57), also done in the mid-1870s and first exhibited in 1876, resulted from a longstanding friendship between the two men (they had first met in Vichy in 1869 as members of a party which also included Adelaide Sartoris and Swinburne). Portraits of men by Leighton are rare – there were very few men with whom he felt sufficiently at ease that he could bring himself to give a direct and incisive account of their personality. That this painting was important to the artist is demonstrated by his having held on to it until his death; it subsequently passed according to his wish to the National Portrait Gallery.

The portrait of Burton is remarkably effective; the artist has dispensed with all peripheral detail so as to concentrate on the rugged and hard-worn physiognomy, and particularly on the burning, menacing, eyes; and it conveys a powerful impression of a man of dynamic and unpredictable temperament. This small painting has the gravity and presence of a portrait of a doge of Venice by Tintoretto. Leighton's English critics seem to have responded to it in conventional terms, but the portrait made a great impression when it was shown at the Exposition Universelle in Paris in 1878. On that occasion the writer Duranty described it as '*si énergiquement peint par M. Leighton*' as to be '*très effrayant*' – '*Il est certain que l'état normal de cette figure, à en juger par la peinture . . . est une expression de fureur.*'

None of Leighton's Academy exhibits since 1871, when he had shown *Hercules wrestling with Death*, had been of the heroic scale which he had established with *Cimabue's Madonna* and *The Syracusan Bride*, but in 1876 he exhibited the largest and most ambitious painting of his career, *The Daphnephoria* (plate 58).

Once again Leighton has taken a processional subject: the spectator is witness to the tribute paid to the god Apollo by the people of Thebes to commemorate their victory over the Æolians. The procession to the Temple of Apollo is led by a priest, seen on the right dressed in a white and gold toga, who carries a branch of laurel in honour of the god; before the priest comes a boy holding a symbolic standard representing the sun, moon and stars; three other boys carry trophies of golden armour; there then follows a choir of women and girls

57. *Captain Sir Richard Burton.* 1875. Oil on canvas, $23^1/_2 \times 19^1/_2$ in. (59.7×49.6 cm.).
National Portrait Gallery, London

who chant a hymn to Apollo; the procession is brought up at the rear by boys carrying golden tripods, also symbols of Apollo. To the left a distant view of the city of Thebes is offered. The atmosphere of this strange, loosely historical, work is distracted and remote. The figures drift forward in informal groups, with dazed expressions as if mesmerized by the rhythms of their own music. Various bystanders casually watch; they also seem affected by the mood of somnolence induced by the singing.

When constructing *The Daphnephoria* Leighton deliberately avoided the strictly horizontal and planimetric arrangement which he had used in his previous processional paintings. The marble pavement upon

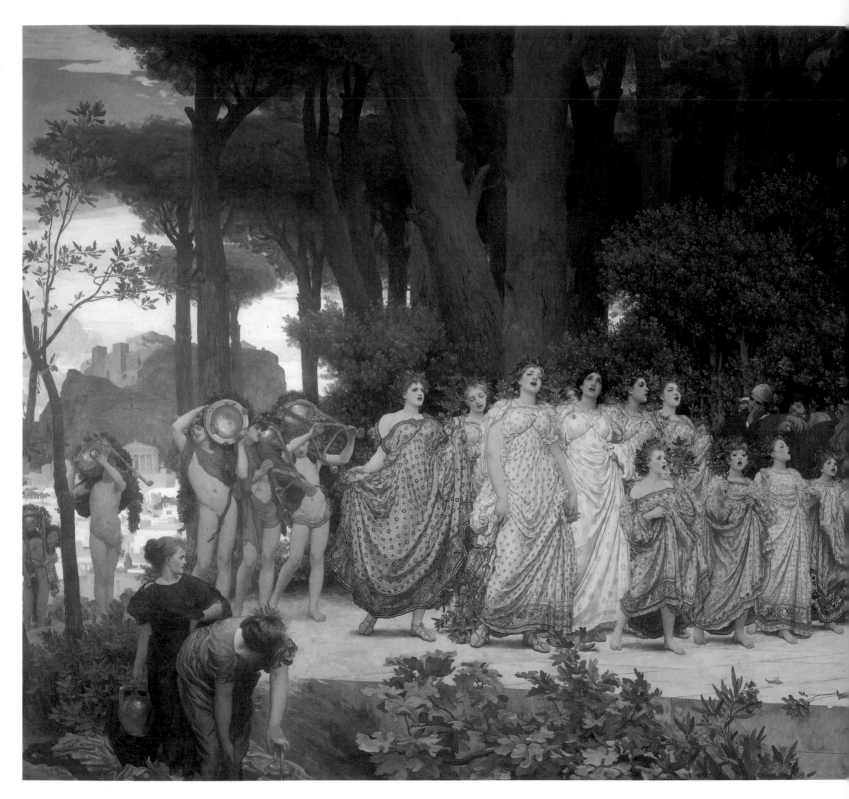

58. *The Daphnephoria*. Exhibited 1876. Oil on canvas, 89 × 204 in. (226 × 518 cm.).
National Museums and Art Galleries on Merseyside (Lady Lever Art Gallery, Port Sunlight)

59. Model of three standing figures for *The Daphnephoria*. Bronze, height: 12¹/₂ in. (31.8 cm.).
The Royal Academy of Arts, London

which the groups stand is seen in perspective, so that its edge makes a long angle across the foreground, and serried ranks of figures merge together as they advance from left to right. The arrangement is not as relentlessly symmetrical as in *The Syracusan Bride* and there is a greater sense of naturalism. Where the spectator expects to be overwhelmed by grandiloquent classicism he encounters charming studies of women and children; and what at first might appear a momentous event from ancient history gradually settles in the consciousness as a mere summer outing in fancy dress.

Leighton worked out the placing of the figures, the forms of the central backdrop of trunks and foliage, and the subsidiary views at left and right, in a series of vivid chalk drawings. Once this distribution was established individual figures and groups of figures were studied from both nude and draped models. To establish exactly how each figure should stand, and in what relation to the next, Leighton made clay models (see plate 59) of the groups, which he could then arrange and re-arrange in different perspectives and physical conjunctions.

The technical quality of the painting is hard to evaluate: the surface is glazed and reflections in the glass make the upper and middle reaches almost impossible to see. But in the reviews of the 1876 Academy exhibition much was made of the richness of colour and line; the *Art Journal* dubbed it 'one of the most gloriously-decorative works ever seen on the walls of the Academy. The limber grace of the young men, and the purity and

60. *Music Lesson.* Exhibited 1877. Oil on canvas, 36¹/₂ × 37¹/₂ in. (92.8 × 95.3 cm.).
Guildhall Art Gallery, City of London

beauty of the maidens, are wondrously soothing to behold. . . . To project such a scene upon canvas presupposes a man of high poetic imagination, and when it is accompanied by such delicacy and yet such precision of drawing and such suavity of modelling, the poet is merged in the painter.' Leighton's friends and acolytes regarded *The Daphnephoria* as a masterpiece: Holman Hunt described it as 'the finest, the most beautiful picture in the world'; while William Blake Richmond wrote that it 'could only have been painted in this century, the classic feeling it demonstrates is of to-day, when the severer forms of classic art appeal to the cultivated with more force than formerly.' *The Daphnephoria* was less a history painting than a decorative machine, calculated to direct the thoughts of the spectator into a remote and indefinite past. It was the quintessential expression of the strain in English modern art at the beginning of the last quarter of the nineteenth century which found in classical subjects the opportunity to evoke moods of wistfulness and escape, and which depended upon the careful orchestration of pictorial elements.

Music and music-making had provided Leighton with subjects for some of his most successful paintings in the 1860s, and his increasing preference for passive and physically static scenes led him to revert to this cat-

61. *Athlete struggling with a Python. c.* 1874–7. Bronze, height: 69 in. (175.7 cm.).
Tate Gallery, London

egory of subject in the 1870s, most notably with *The Daphnephoria*. A more intimate painting of this type is *Music Lesson* (plate 60), which was exhibited at the Royal Academy in 1877. It shows a woman helping a girl to play an oriental guitar; she extends her left arm to tune the instrument and with her right hand places the child's fingers on the strings. The couple are united by an affection of a kind previously expressed in *Sisters*.

In *Music Lesson* Leighton gives a dazzling display of his command of textures. The *Art Journal* referred to the work's 'sensuousness of finish' and a 'quality of preciousness'. The visible surfaces of the building which provides the setting are patterned with variegated marbles, the geometrical forms of which provide a grid of horizontals and verticals across the background. The two figures create a loosely pyramidal shape at the centre; and Leighton's habitual fondness for the counterpoint of similarity and contrast is expressed in the luxuriance of silk flowing downwards over the girls' bodies seen against a severe rectangular background.

As a painter Leighton thought in three-dimensional terms, and he was careful to place the forms of his compositions in a logical perspective. He was also interested in the practical possibilities of modelling figures,

Figure 2. *Etched portrait of Sir Frederic Leighton, c.* 1878, by Alphonse Legros (1837–1911).
Collection of Christopher Newall

both as a means of experimenting with different arrangements in the process of building up large-scale painted compositions, and as a preparation for independent sculptures cast in bronze. During the mid-1870s he was engaged on a life-size group entitled *Athlete struggling with a Python* (plate 61), which was to be made in bronze and later carved in marble. The subject, which must derive in a general way from the Roman antique statue *Laocoön*, was first explored in a small model and in thumbnail pencil sketches. The French sculptor Jules Dalou saw these and encouraged Leighton to attempt a finished and large-scale group. This Leighton worked on in the studio, and with the assistance, of his friend Thomas Brock; in due course the work was cast, and was exhibited at the Royal Academy in 1877.

The realism of *Athlete and Python* is reminiscent of late nineteenth-century French bronze sculpture. As with his painted subjects Leighton's sculpture may be said to be not so much influenced by specific examples as a constituent part of the mainstream of European artistic development. *Athlete and Python* represents an extraordinary contrast to the balance and serenity of most of Leighton's painted subjects of the 1870s; although it is anticipated in its tension and dynamism in the figures locked in struggle in *Hercules wrestling with Death*. It serves no purpose except the exploration of muscularity and physical strength; human limbs strain to fight off the relentless embrace of the snake, and it is not clear who the victor will be in this terrifying clash of primal forces. The sculpture released Leighton from the requirements of a single viewpoint and he paid careful attention to the way the group would appear from different angles of vision.

The statue made a sensation at the Academy and was bought for the nation by the Chantrey Bequest. It was, as the *Art Journal* wrote, 'nobly classic in feeling, yet full of such realistic detail as modern anatomical knowledge demands'. Edmund Gosse described the sculpture as 'something wholly new, propounded by a painter to the professional sculptors, and displaying a juster and a livelier sense of what their art should be than they themselves had ever dreamed of. "The Athlete and the Python," . . . gave the start-word to the New Sculpture in England.'

Something of the same quality of physical dynamism, although seen on this occasion in anguished repose rather than violent struggle, imbues Leighton's painting *Elijah in the Wilderness* (plate 62), which was first exhibited at the Exposition Universelle in 1878. Elijah loomed large in the Victorian consciousness; Mendelssohn's oratorio, first performed in England in 1846, may have contributed to an interest in the Old Testament prophet. In 1862 Leighton had told the Dalziel brothers that he was particularly interested in the story of Elijah and Jezebel and a year or so later he was to paint *Jezebel and Ahab, met by Elijah*. *Elijah in the Wilderness* takes its subject from Chapter 19 of Kings I, which describes how the prophet had fled into the desert of Judah to escape the revenge of Jezebel following his triumphal demonstration of the power of the Lord on Mount Carmel. The painting was an important one to the artist; Mrs Barrington reported Leighton as saying that he 'had put more of himself into that picture than into any other that he had ever invented'.

Clearly Leighton believed that religious subjects required a more forthright and pictorially dramatic approach than reconstructions of the ancient world. The gigantic figure of Elijah, nude except for a loin-cloth, lies back on a tobacco-coloured cloth in an abandoned posture. His right foot and left elbow press against the edges of the composition and the figure seems to seek to cast off an unseen physical constriction. The contorted pose is derived from that of the famous *Barberini Faun* in Munich, which Leighton would certainly have seen as a young man, and is one of the most direct quotations from a classical prototype to occur in Leighton's work. As was the case with Leighton's first painting of Elijah, the heroic scale and strength of the figures are reminiscent of Italian baroque painting; the classical balance of the ministering angel suggests the work of the Carracci or Lanfranco; and the knotted muscularity of Elijah the work of Caravaggio or Ribera. As Costa remarked, 'Leighton had never lost sight of the old masters, though he never was a mere imitator of them.'

Elijah belonged to a class of painting which would never be popular in England; its overt religiosity was off-putting to Leighton's Protestant compatriots, and it was not by chance that the picture was first exhibited in Paris. The culturally ambivalent character of Leighton's art, and his remoteness from English tastes and preoccupations, were remarked by the *Athenaeum*: 'It is rather difficult to know in what category to place Mr. Leighton's works . . . They are dissimilar to any English work, and we know no foreign school to which they are distinctly allied . . . We suppose they may be taken as cosmopolitan; they are the work of a consummate master; they compel our admiration, but they do not sway our hearts, as they would if the artist deigned to look down on this poor, workaday England of ours.'

Among the four paintings which Leighton exhibited at the Royal Academy in 1878 were two which exemplified different aspects of his Hellenism in the middle years of his career, *Nausicaa* (plate 63) and *Winding the Skein* (plate 64). The first is inspired by an event in Homer's *Odyssey*, but the mythological story is a mere pretext for a formally pleasing study of a young woman leaning against a pilaster. The painter has sought to express Nausicaa's state of mind as she bids farewell to Odysseus, to whom she has lost her heart.

62. *Elijah in the Wilderness*. Exhibited 1878. Oil on canvas, 92$^{1}/_{2}$ × 82$^{3}/_{4}$ in. (235 × 210.2 cm.).
National Museums and Galleries on Merseyside (Walker Art Gallery, Liverpool)

63. *Nausicaa*. Exhibited 1878. Oil on canvas, 57¹/₂ × 26¹/₂ in. (146 × 67.3 cm.). Private collection

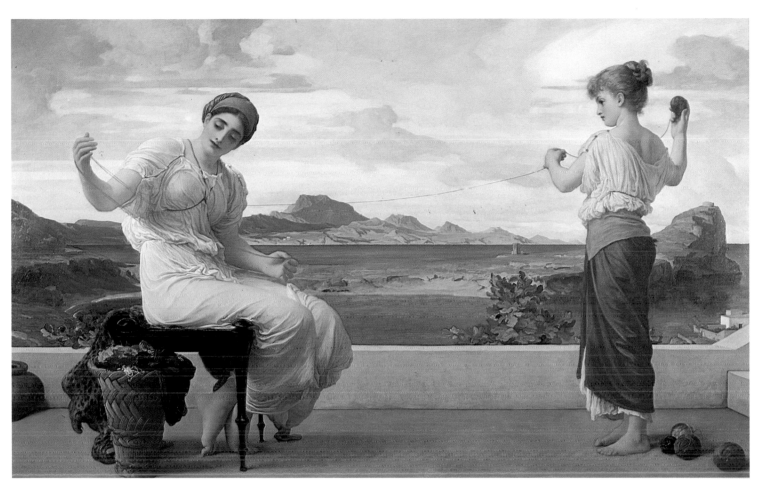

64. *Winding the Skein*. Exhibited 1878. Oil on canvas, 39$\frac{1}{2}$ × 63$\frac{1}{2}$ in. (100.3 × 161.3 cm.).
Art Gallery of New South Wales, Sydney

Winding the Skein represents a woman and a child winding wool in the open air. The models are those previously seen in *Music Lesson*; the younger of the two may be identified as Connie Gilchrist, a child actress also painted by Whistler. Domestic and genre subjects in vaguely antique settings had become popular with the Neo-Greek school of painters in France, of which Gérôme and Bouguereau were members, and had been adopted in England by Lawrence Alma-Tadema. This work was a deliberate attempt on Leighton's part to appeal to a wider public, and in 1884 the Fine Art Society published a photogravure of the painting which circulated widely. The subject did not, however, bring out the best in the artist: he relied upon decorative qualities and the artful arrangement of pictorial properties to set off a pleasant but unexciting scene, and the lack of action has not been compensated by sense of mood. The *Magazine of Art* concluded: 'Mr. Leighton paints trivial subjects for his admirers, and great ones for the love of art. The public accepts him purely as a decorative painter, yet we detect far loftier aims than the ends of decoration in some . . . works of noble interest [in which number the reviewer included *Elijah in the Wilderness*] which he has given to the world.'

The draperies of the two figures in *Winding the Skein* are extremely elegant, and their relaxed postures result from careful observation of the nude model. Once again the painter organized the composition to give an abrupt conjunction of foreground – the terrace on which the figures are placed – and the distant view over a mountainous coastline and the sea. He may have resorted to this formula because he felt that a more gradual recession into distance, and the requirement of a more crowded immediate environment for his figures, would disturb their classical poise. On the other hand he may have been uncertain as to how to manage the middle ground which would provide a more natural perspective into distance. Whatever the case, an uncomfortable impression is given of the figures, real enough in themselves, being placed against an unrelated backdrop.

The meticulous finish of Leighton's paintings was, even as early as the late 1870s, beginning to appear dated. There was a new appreciation of spontaneity in works of art, and the mid-Victorian delight in a style of painting which seemed to replicate nature was giving way to an understanding of how an artist, by a more spirited handling of paint, might express qualities which mere facsimile could not convey. A criticism increasingly heard of Leighton's work was that the flesh tones were waxy and bloodless, and not those of living models. *The Times* reviewer asked of *Winding the Skein*: 'Could not as much beauty and as much grace be given with truer indication of the tissues and the current of life under them, and yet with no disagreeable suggestion of vulgar realities of life?' The curious fact was that Leighton had the ability to paint in the most fluent and expressive way – his oil studies of landscape and figures have an impressionist brevity and directness – and yet he was for some reason inhibited from allowing a looser or more spontaneous style in the works which he produced for public display.

In the autumn of 1878 Sir Francis Grant, the longtime President of the Royal Academy, died. Leighton heard the news when staying with Costa at Lerici on the Ligurian coast of Italy, and it seems that he assumed at once that he would succeed to the most powerful position in English artistic life. Leighton, for whom a knighthood marked his accession to the Presidency, represented the Academy's best hope if it was to survive as a useful and relevant body of artists.

3

The President of the Royal Academy, 1878–1896

Leighton exhibited eight paintings at the summer exhibition of 1879, the first year of his Presidency of the Royal Academy. The most important of these was *Elijah in the Wilderness*, which had been previously shown in Paris. Several were charming but bland representations of girls or young women in domestic surroundings or out of doors, such as *Amarilla* (plate 65), a type of subject which was to become more frequent in Leighton's output as well as an increasingly familiar feature of late Victorian art in general. These are too vague and unspecific to be considered as portraits, and too remote from the realities of daily life to be accepted as works of honest genre.

Two remarkable paintings shown in 1879 were actual portraits. One was of Leighton's old friend Giovanni Costa (untraced), who hangs his head dejectedly and appears to submit unwillingly to the process of being painted. Costa later described the stages through which the work had gone: 'For this portrait [Leighton] had four sittings – one for the drawing and the monochrome chiaroscuro, one for the local colours; then, having covered all with grey, he painted the lights with red, white and black, making use of the thoroughly dried grey beneath for his half-tints. With scumbles he completed the colour and the modelling.'

The second portrait, *The Countess Brownlow* (plate 68), offers no psychological insights, and has, rather, a quality of decorous and formal remoteness. Lady Brownlow is seen in an open landscape, the distant horizons of which suggest an aristocratic demesne. This setting was painted from studies made in the park at Ashridge, the Brownlows' house in Hertfordshire. Even more evocative of the English landscape is the towering cumulus cloud which rises up behind the standing figure. Leighton deliberately offers the spectator an angle of vision which allows the statuesque figure of Lady Brownlow to dominate her surroundings against a backdrop of sky. As a result she seems immensely tall, and somehow not an inhabitant of the real world. The sculptural quality is further enhanced by the rich folds and three-dimensionality of her draperies. Her dress is demurely gathered at the neck but flows out in copious folds and cascading layers below the waist. With her left hand she elegantly lifts the hem free from the ground. This dress, a kind of cream and white toga, is a clue to Lady Brownlow's advanced ideas on aesthetic matters and her sympathy for neo-classicism in matters of taste.

If the portrait of Mrs Guthrie, painted thirteen years previously, was the product of a Venetian influence upon Leighton at the end of his early career, *The Countess Brownlow* represents the consummation of his classical style of painting in the 1870s. The earlier painting is dark and obscure over much of its surface, whereas the painting of 1879 is lambent with evening light. Mrs Guthrie's pallid complexion is emphasized by her shadowy surroundings, and her physical frailty suggested by the pieces of furniture upon which she almost seems to lean for support. By contrast, Lady Brownlow is the figure of health, the colour of her cheeks brought out by the crimson of the roses she is holding. The portrait has a forthright and confident character, in part suggested

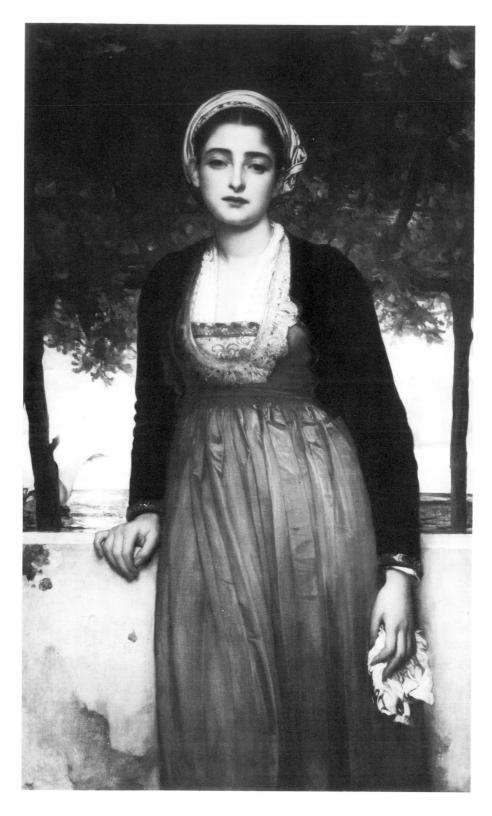

65. *Amarilla*. Exhibited 1879. Oil on canvas, 49¹/₂ × 29 in. (125.7 × 73.7 cm.). Private collection

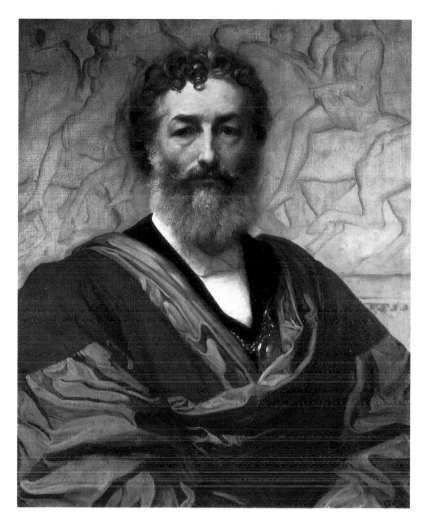

66. *Self-portrait.* 1880. Oil on canvas, 30¹/₈ × 25¹/₄ in. (76.5 × 64.1 cm.). Uffizi Gallery, Florence

by the personality of the subject but also symptomatic of Leighton's own artistic inclinations at this stage. She stands in the forefront of the spectator's vision, elegant but immutable; feminine and charming with at the same time the appearance of a Greek caryatid. Lady Brownlow perhaps represented an ideal of female beauty to Leighton: in his Academy Address of 1883 he surmised: 'In the Art of the Periclean age . . . we find a new ideal of balanced form wholly Aryan, and of which the only parallel I know is sometimes found in the women of another Aryan race – your own.'

The criticism has been made of Leighton's portraits that they reflect the sitters' own vision of themselves rather than the artist's. When in 1880 Leighton painted a *Self-portrait* (plate 66) for the historic collection of artists' self-portraits held by the Uffizi Gallery in Florence, he had the opportunity to combine the expectations of painter and patron. Perception of character or simple reliance on an ability to draw the contours of a face was not enough on this occasion. Leighton was too aware of the importance of his own position, and perhaps too insecure as a man, to omit reference to his office or allusion to his role as an artist: he portrayed himself

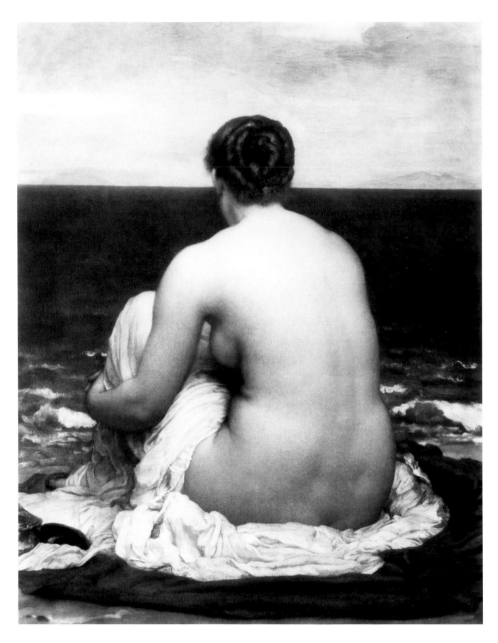

67. *Psamathe*. Exhibited 1880. Oil on canvas, 36 × 24 in. (91.4 × 61 cm.).
National Museums and Galleries on Merseyside (Lady Lever Art Gallery, Port Sunlight)

wearing academic robes into which is tucked the gold seal of the President of the Royal Academy; while the background consists of a section of the Parthenon frieze from the British Museum, a copy of which he had set up in the studio of his house in Holland Park Road.

Leighton can hardly be blamed for offering the Uffizi such a conventional image of himself – he was understandably proud of the position which he had gained in public life. Furthermore, it seems that the portrait gave an accurate enough account of the fifty-year-old painter's appearance, for he wrote to Costa in the summer of 1880: 'I am finishing my portrait for the Uffizzi Gallery . . . It is like, very like!'

In 1880 Leighton exhibited a painting entitled *Psamathe* (plate 67), which shows the figure of a woman, nude except for a drapery spread over her thighs, whose back is turned to the spectator as she gazes out to sea.

Although similar in terms of subject to his *Actaea, the Nymph of the Shore* of 1868 (Psamathe was a sister Nereid to Actaea), the 1880 work demonstrates the extent to which formal and technical considerations had come to dictate the style of Leighton's paintings of nude subjects. The work consists of a softly outlined and richly volumetric triangle placed within a more severely defined system of rectangles. As ever the outlines are manipulated to give a rhythmic pattern of shapes: the woman's shoulders and back show palely against the deep blue of the sea; her head and coiled hair, which break the line of the distant shore, are seen in dark silhouette. *Psamathe* was a pretext for a bravura display of textures – as seen in the woman's skin, her cascading draperies and the gently washing waves.

The uncertainty which Leighton had once shown in the representation of the female nude had given way to a more spontaneous delight in undraped forms. The painter continued to make studies, both drawn and painted, of nude models. An example of this type of exercise, done by Leighton for the sheer pleasure of looking and recording what he saw, is an impromptu and highly personal oil study, *Standing Nude Figure, seen from behind* (plate 69).

Leighton continued to paint the landscape and natural forms. Studies such as *Trees at Cliveden* (plate 75) explore the rhythms and patterns which may be observed in nature. In his late landscapes he dispenses with the conventions by which English painters had traditionally made the face of the countryside inviting to their audience, preferring to simplify and make abstract shapes and colours of unidentified topography. In his later years Leighton enjoyed painting in remote parts of Ireland and Scotland and he came to delight in the subtlety of the soft and muted colours of the landscape of the British Isles.

The emphasis of Leighton's work was changing as he moved towards the last phase of his career. Where previously he had painted subjects which engaged the sympathy of the spectator by theatrical means, he now more frequently chose peaceful scenes where the emotional charge was richer and less histrionic, and he often dispensed with the physical barriers which he had formerly used to restrict his figures. None the less, the character of these works is idyllic; their naturalism belies the remoteness and dispassionate quality of their subjects, which in turn seems to seal them hermetically and frustrates the desire of the spectator to savour their moods more fully.

Idyll (plate 72) is the fulfilment of this new feeling for intimacy and passivity. Two scantily dressed women, one supporting herself on her left elbow, the other lying back and resting her head on the bosom of her companion, are sleepily absorbed by the sound of music played by a seated shepherd, whose back is turned to the spectator. The title refers in a general sense to the *Idylls* of Theocritus. The female figures are intended for dryads, nymphs of the forest who have emerged at eventide from the bosky world which they inhabit to be bewitched by the power of pastoral music. However, the shepherd is playing to his animals and seems unaware of his female companions, who in any case will disappear when the music ceases and night falls. The symbolism depends upon the contrast of the rugged and sun-browned back of the man, suggestive of the vigour of mortal life, and the enervate bodies of the women, which together echo the shape of the branch beneath which they lie. He is seen in robust outline against the distant sea; they are ethereal in their gauze-like draperies, while their more sombre outer garments fuse with the colours of the earth and tree-roots.

With *Antigone* (plate 71) of 1882 Leighton demonstrated that he had not lost interest in the representation of more specific mythological subjects, nor indeed entirely abandoned histrionic themes inspired by classical tragedy. Antigone was condemned to death for having carried out the ritual burial of the body of her

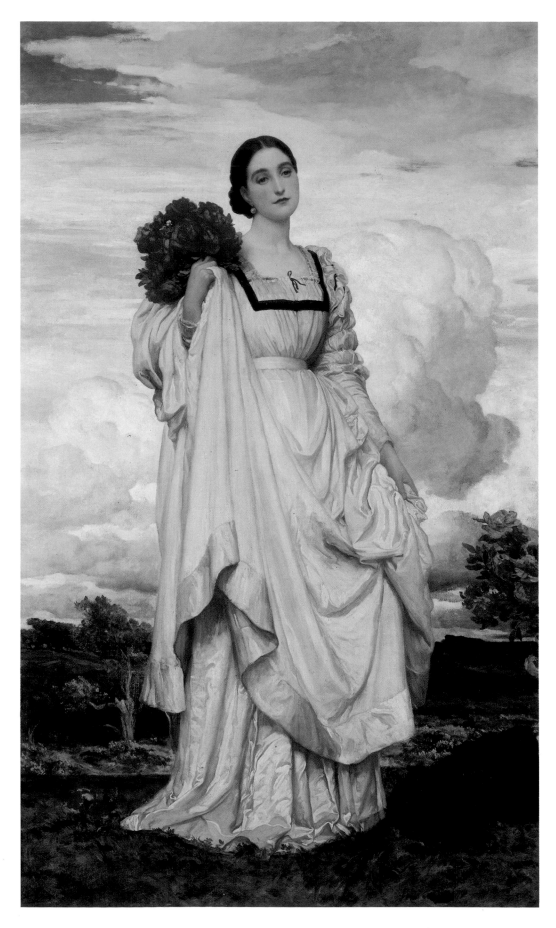

68. *The Countess Brownlow.* Exhibited 1879. Oil on canvas, 92 × 52 in. (233.7 × 132 cm.).
The National Trust, Belton House

69. *Standing Nude Figure, seen from behind.* Oil on canvas, 22 × 10¹/₂ in. (55.9 × 26.7 cm.).
Private collection

70. *Cymon and Iphigenia*. Exhibited 1884. Oil on canvas, 64 × 129 in. (162.5 × 327.6 cm.).
Art Gallery of New South Wales, Sydney

brother Polynices. Before the sentence that Creon, King of Thebes, passed upon her was carried out Antigone hanged herself.

For his portrayal of Antigone Leighton used the model who was to become an inspiration to him in his later years, Dorothy Dene. She was herself an actress with a repertoire of tragic roles; opinions differed about her talent on stage, but she gained certain immortality as the central figure in a series of powerful works by Leighton. In this painting her head is thrown back in anguish; the deliberate way in which her neck is exposed to the spectator's view invites contemplation of Antigone's self-inflicted death. F. G. Stephens was very impressed by this work: 'The face [is] full of expression and noble in form. The head is turned sideways to our left and a little raised, the lips are open in the act of speaking, and the eyes render an ideal of passionate suffering and an appeal to the higher powers.'

The theatricality and violence of *Antigone* are in marked contrast to the subtle exploration of mood in *Idyll*. A painting which draws on both artistic means is *Cymon and Iphigenia* (plate 70), which Leighton exhibited at the Royal Academy in 1884. The story is taken from *The Decameron* of Boccaccio. Cymon, a simple shepherd boy, stumbles across the sleeping figures of Iphigenia and her attendants in a grove by the sea. One sight of the radiant beauty of the girl is enough to make him realize the incompleteness of his own rustic existence; he gazes longingly at her and is for a moment spellbound.

The painting shows the moment when, in Leighton's words, 'the *merest lip* of the moon has risen from behind the sea horizon, and the air is haunted still with the flush of the after-glow from the sun already hidden in the west'. He described this effect as 'the most mysteriously beautiful in the whole twenty-four hours'. A

104

71. *Antigone*. Exhibited 1882. Oil on canvas, $23^{3}/_{4} \times 19^{1}/_{2}$ in. (60.3×49.5 cm.). Private collection

purple tinge invests the composition with a strange and magical quality, and everything is seen in the half-light of dusk, except for the draped figure of Iphigenia, which somehow catches the last embers of evening light and glows with luminous colour. A curious sense of transience is conveyed: the eerie light effect will last only as long as the combination of sunlight and moonlight is maintained, a fleeting moment which seems to pass before the spectator's eyes even as he watches.

Leighton had long sought to create a work which would stand before the widest possible public. The opportunity seemed to have arrived when in the mid-1870s it was proposed to complete Alfred Stevens's earlier scheme for the decoration of the dome of St Paul's Cathedral. Leighton was to collaborate with E. J. Poynter and Hugh Stannus, and undertook to design eight mosaic roundels of subjects from the Apocalypse. In the event only the first, *'And the sea gave up the dead which were in it'*, was worked on. Poynter's cartoon for the

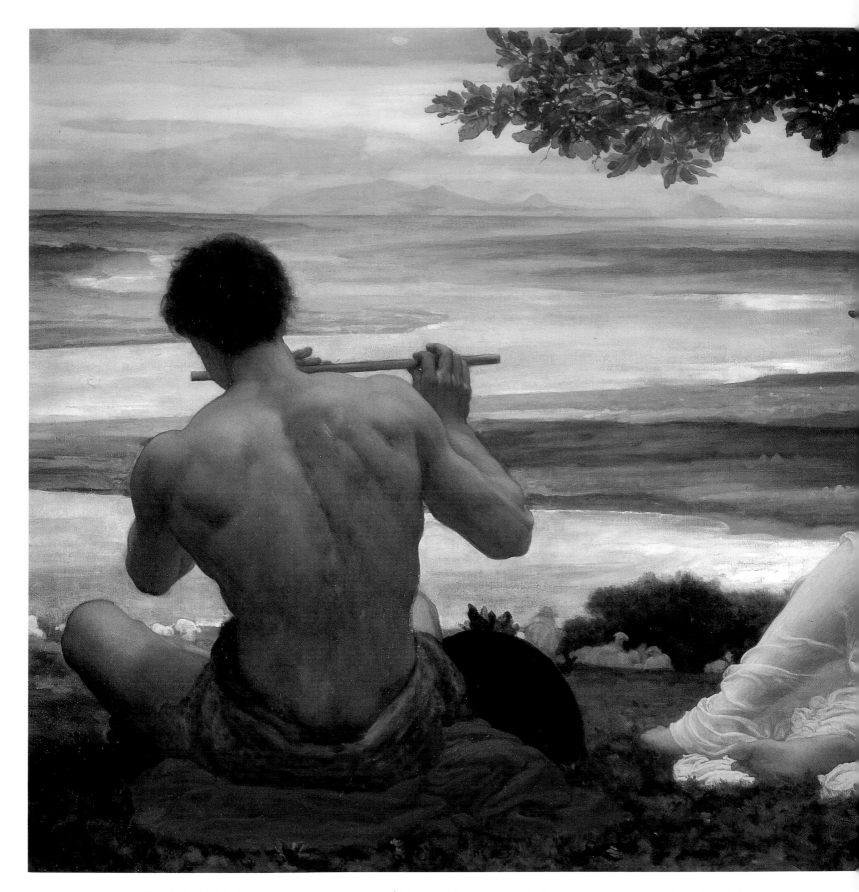

72. *Idyll*. Exhibited 1881. Oil on canvas, 41 × 83¹/₂ in. (104.1 × 212.1 cm.). Collection of Mr and Mrs Henry Keswick

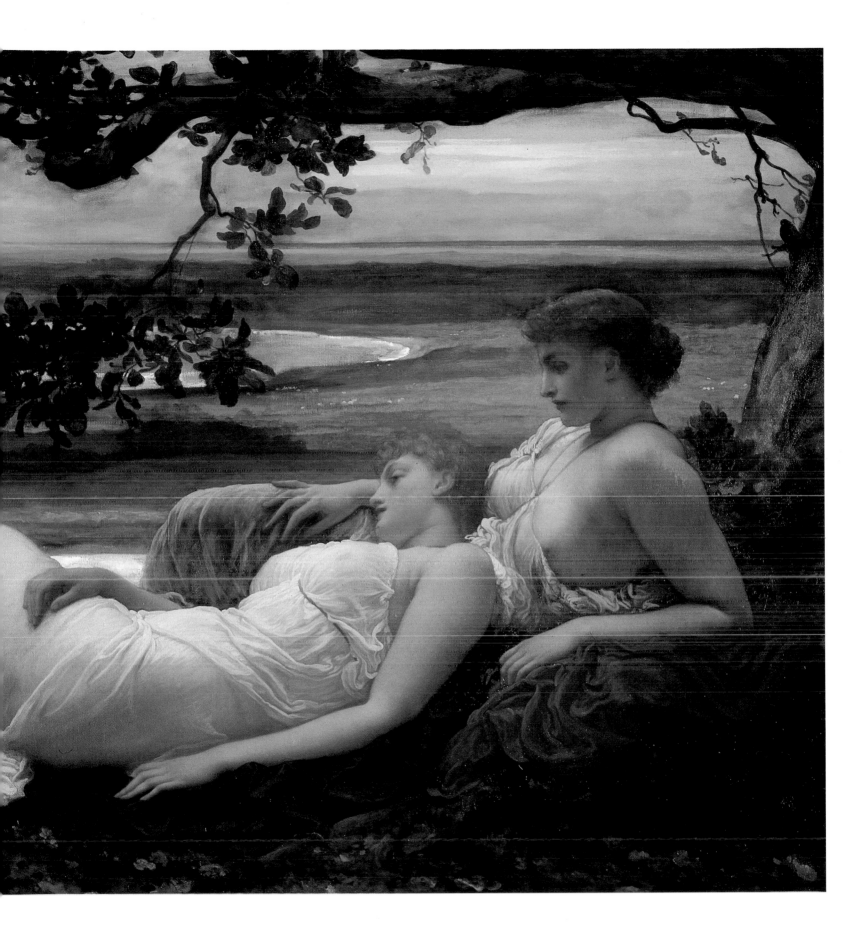

73. Sketch for the Marquand ceiling. *c*. Oil on canvas, 11¹/₂ × 32¹/₂ in. (29.2 × 82.5 cm.).
Collection of James Draper

scheme was placed in the dome but met with virulent opposition, and by the middle of the 1880s the project was abandoned.

Leighton must have been disappointed by this setback. His single completed design has been lost, but the way in which he met the problems of creating a work of art which would be viewed at a great height within an enormous interior may be judged from the reduced replica which he later made for Henry Tate (see plate 89). The circular composition shows nude and draped figures shrugging off the sleep of death and rising from their watery graves to salvation. The male figures have the powerful muscularity previously seen in *Elijah in the Wilderness*.

In the early and mid-1880s Leighton received various commissions to design and execute decorative schemes for the interiors of private houses. One was for the drawing-room of the Mayfair house of the wealthy stockbroker Stewart Hodgson, who had previously commissioned *The Daphnephoria* for his house in Surrey. Leighton conceived two frieze-like panels on the themes of Dance and Music; the finished paintings (London, Leighton House), or sketches for them, were exhibited at the Royal Academy in 1883 and 1885 respectively. Each panel consists of a symmetrical arrangement of figures, some of which participate in the activity.

For a ceiling decoration undertaken for the music-room of the New York mansion of the American tycoon and patron of the arts Henry Gurdon Marquand, Leighton devised a tripartite arrangement (for the oil sketch for the scheme see plate 73). In the centre panel a seated figure is flanked by the muses Euterpe and Thalia; the two upright side panels contain the muses Erato and Terpsichore, who are accompanied by naked boys (for the drapery study for Terpsichose see plate 74). The iconographic content was perhaps sugested by Henry Marquand, who had a taste for neo-Greek and Roman works of art. The poet Swinburne was consulted about the roles of the muses represented.

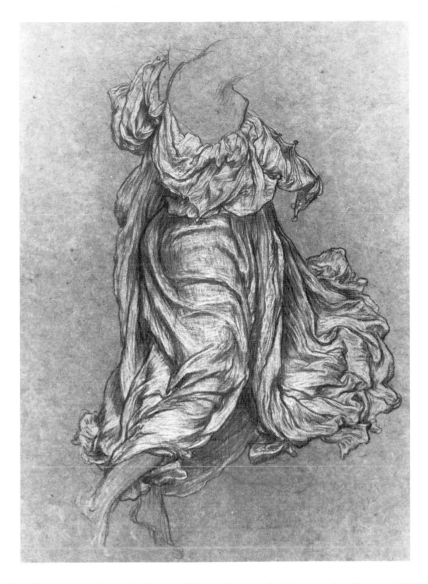

74. Drapery study for the figure of Terpsichore in the Marquand ceiling. *c*. 1886.
Black and white chalk on brown paper, 19⁷/₈ × 14¹/₈ in. (50.5 × 35.8 cm.). Private collection

In his late paintings Leighton achieved an extraordinary freedom and fluency in the handling of colour and the manipulation of texture. Works such as *Gulnihal* (plate 76), exhibited in 1886, show a new and more relaxed attitude as to what was appropriate for public display, and are in fact barely modified expansions of the type of close-up figure study that Leighton habitually made. In *Gulnihal* a young girl with red hair and wearing an apricot-coloured coat turns her head in near profile. The texture of her fine fair, the delicate softness of her skin, her grey eyes lit with extraordinary subtlety, are all beautifully rendered. Light is cast on the wall before which she sits, and here Leighton has resorted to an audacious use of the palette knife to lay on jagged layers of white and blue to achieve the effect of glaring reflection.

Leighton made another foray into the field of sculpture in 1886 with *An Athlete awakening from Sleep*, better known as *The Sluggard* (plate 77), which he had worked on over a number of years. A standing nude male figure is shown stretching his leanly athletic body, either in a state of exhaustion or as he shakes off the effects of sleep. The weight of the figure falls on the left foot; the trunk and shoulders are dramatically twisted

75. *Trees at Cliveden.* Oil on canvas, 17 × 10¹/₂ in. (43 × 26.6 cm.). Collection of Mr and Mrs John Gere

76. *Gulnihal*. Exhibited 1886. Oil on canvas, 22$\frac{1}{4}$ × 17$\frac{1}{4}$ in. (56.5 × 43.8 cm.).
Private collection, Switzerland, by courtesy of Julian Hartnoll

77. *The Sluggard. c.* 1882–5. Bronze, height: 75 in. (190.5 cm.). Tate Gallery, London

and tense with straining musculature; the arms are raised; and the head falls back almost uncontrollably. F. G. Stephens commented: 'The style of the sculpture is much more naturalistic than that of the quasi-archaic Python-slayer, and much more knowledge is displayed throughout.' *The Sluggard* was an indulgent and light-hearted exercise, which attracted attention not for its overall impact as a work of art but for the highly skilful treatment of the nude body, and some contemporaries assumed that there was a deliberate contrariety between the two sculptures.

The second sculpture which Leighton exhibited in 1886 was a work of unashamed genre. Entitled *Needless Alarms*, it showed a naked child looking down at a frog crawling at her feet. Both *The Sluggard* and *Needless Alarms* came to be known to a wide public in the 1890s when large numbers of bronze statuettes, reduced versions of Leighton's originals, were manufactured and sold by fine art dealers.

By the middle of the 1880s Leighton had gained a position of authority in English artistic life. The Royal Academy showed signs of revival and the challenge which the Grosvenor Gallery had once seemed to represent had passed. Leighton's role as archimandrite of English art was confirmed by the fact that his style of painting, although never as popular as Frith's or even Millais's scenes of modern life and comfortable domesticity, was accepted by the majority as the highest and most prestigious level to which the art could aspire.

Leighton had no pupils in the normal sense. His teaching went no further than the impersonal and abstract Addresses that he made to the students of the Royal Academy. Younger painters were not admitted to his studio when he was at work, nor for the most part did he employ assistants. He supported various younger painters, for example W. E. F. Britten, with advice and recommendations, but more because he found them personally agreeable than because he saw in their works the possible continuation of a tradition which he had sought to establish. However, there were a number of painters whose styles of art were loosely dependent upon Leighton's, Edward John Poynter and William Blake Richmond being the most distinguished, and even after the turn of the century Leighton was admired and imitated by a younger generation of acolytes, whose reputations have not, in the main, survived.

Despite his primacy as a painter, or perhaps because of it, Leighton was the object of criticism and envy. Increasingly, charges of intellectual and spiritual shallowness were levelled against his works. The American writer Henry James despairingly concluded in his essay on Leighton's memorial exhibition that there was in his work 'so much beauty and so little passion, so much seeking, and, on the whole, so little finding'. James gave a scathing portrait of Leighton in a short story entitled *The Private Life* in the guise of a character called Lord Mellifont, who existed only to be congratulated and admired for his conduct of the role of artist. Leighton's near contemporary and sometime friend Edward Burne-Jones was baffled by the President's apparent detachment: he confided to his friend T. M. Rooke: 'I always think of him less as an artist than as a highly-cultivated gentleman who paints; someone of more than usual talent, industry and acquirements who chooses to occupy himself in that manner.' The best-remembered comment on Leighton's professional character was made by James Whistler who, having just heard a paean of praise of Leighton's many accomplishments, inquired: 'Paints too, don't he?'

The charge which continued to be brought against Leighton was that his style of painting was not a true product of an indigenous school of art. After Leighton's death W. B. Richmond wrote: 'The more eclectic nature of Leighton's studies, his conservative nature, and his wide knowledge of Continental art, of ancient as well as modern times, gave intention to a cosmopolitan rather than an insular determination, and technique . . . difficult for the British character to accept. . . . The more delicate and subtle shades of Leighton's art . . . are not only foreign in a degree to our national tendencies, but some are even regarded by Philistines with a suspicion of insincerity.' The mounting sense of artistic nationalism led to a feeling of opposition to Leighton as President of the Royal Academy and a belief that a more popular and accessible artist, such as Millais, would have been more suitable to the office; 'for brilliant and superb as the "article" chosen was', remarked George Dunlop Leslie, 'it cannot be denied that it was nevertheless one that had been "made in Germany".'

Gradually the mood of English art was changing, as society itself shed the optimism and industriousness of the High Victorian age: younger painters and critics looked for delicate and poignant qualities in works of art, haunting refrains rather than crashing symphonies, and impressions which evoked a personal experience of places and things rather than laborious and literal transcriptions. A series of articles critical of Leighton

78. *Captive Andromache.* Exhibited 1888. Oil on canvas, 77$^{1}/_{2}$ × 160$^{1}/_{4}$ in. (196.8 × 406.5 cm.). Manchester City Art Galleries

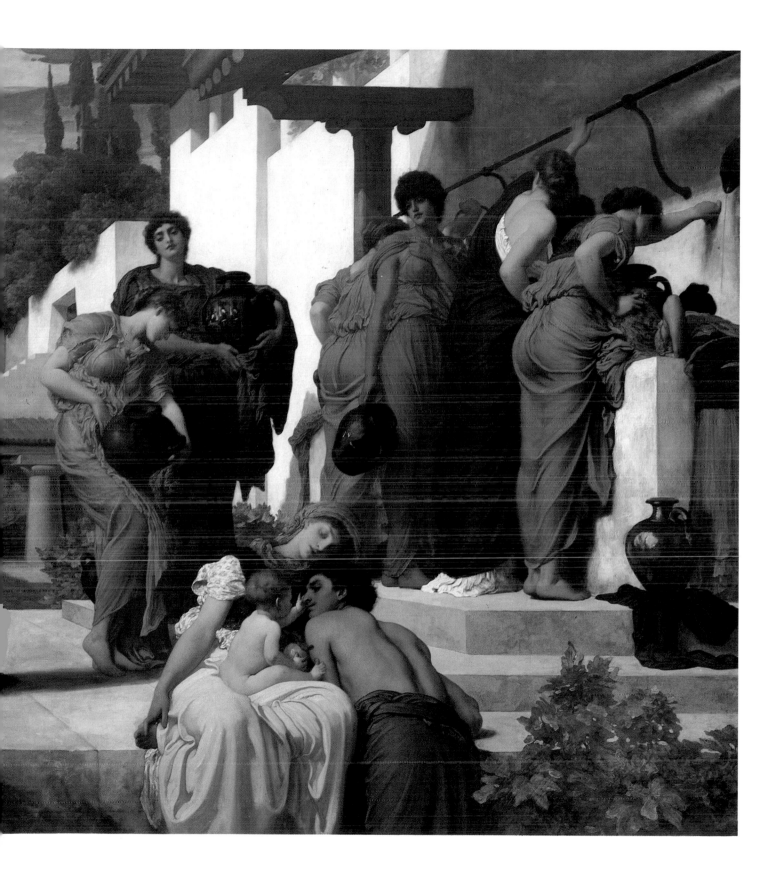

appeared from 1886 onwards in various newspapers and periodicals. According to Staley: 'In 1889 the fashion of running Leighton down had become all but universal – only the very elite of the art world remained true.' Leighton, who had struggled so long to be accepted by the English art establishment, was to find that even when he was on the inside he had to face the hostility of his contemporaries.

In 1888 he exhibited the enormous and multi-figured *Captive Andromache* (plate 78), a work which concluded his great series of processional paintings. As was so frequently the case in his large-scale works the subject of the painting was only obliquely suggested by a literary text. The scene represented by Leighton shows Andromache in her captive state standing among the women of Epirus, waiting her turn to draw water from a well. When exhibited at the Royal Academy an accompanying text from Elizabeth Barrett Browning's translation of Homer's *Iliad* was provided:

> Some standing by,
> Marking thy tears fall, shall say 'This is she,
> The wife of that same Hector that fought best
> Of all the Trojans when all fought for Troy.'

In fact Leighton treats the theme as a mere pretext for the representation of a symbol of isolation and alienation. In this sense the function of *Captive Andromache* is analagous to that of *The Daphnephoria*, although quite different in mood. The two paintings may be seen as counterparts in their wider historical setting; the first representing a people's expression of gratitude for victory in battle, while the second shows the tragic victim of defeat.

Captive Andromache is full of incidental activity and delightful detail, and yet every element is orchestrated to support the main theme. The compositional dynamic is more subtle and rhythmic than in Leighton's earlier processional paintings. In *The Syracusan Bride*, for example, the figures seem to move physically and in a closely regulated crocodile across the surface; here, however, although an approximately symmetrical balance is maintained, there is greater variety of spacing and more complex arrangement in perspective. The figures seem not to be restricted to a prescribed position within a system of planes, but rather occupy a naturalistically observed three-dimensional space. Those at the right are raised up in the composition, as they stand on steps before the well; those on the left are more distant from the point of vision and are commensurately smaller. The immediate foreground is made up of the half-length figures of men, and of a couple with a baby, who break the line of the pavement upon which the mass of the figures are placed. Andromache stands in physical isolation, framed by the open sky, and is the compositional focus of the painting; its symmetrical elements depend upon her figure for a fulcrum.

As has been seen before in Leighton's more elaborate paintings contrariety is combined with a rhythm of shapes which depends upon symmetry and consistency. The right half is brightly lit, and the figures are draped in robes of brown, red and gold; those on the left stand in the shadow of a battlement, and are dressed predominantly in cold colours. Again this pattern is interrupted by the figure of Andromache, enveloped in a heavy black robe and head-dress, and whose face is seen in shadow.

The women go about their task of drawing water, and a curious sense of mundaneness strikes the spectator. One of the two brown-cloaked men in the foreground gestures towards Andromache, while the couple at

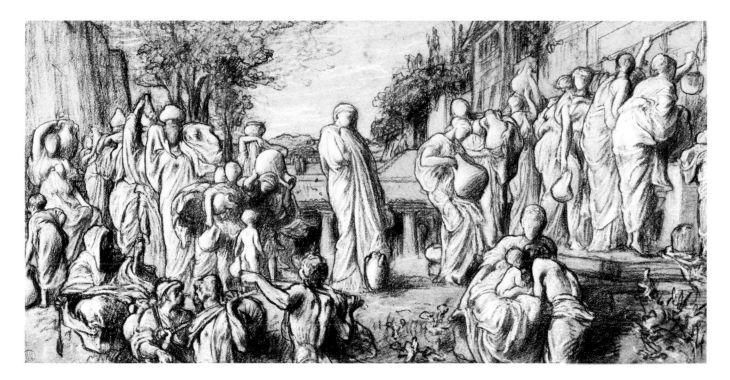

79. Compositional study for *Captive Andromache*.
Black and white chalks on blue paper, 7¹/₂ × 15¹/₈ in. (19 × 38.4 cm.). Manchester City Art Galleries

the right-hand side play happily with their baby. As with *The Daphnephoria* the narrative gist of the subject hardly seems to justify the scale and elaboration of the painting.

Leighton had the idea of the painting in mind for many years; studies of the overall composition occur as early as the mid-1870s (see plate 47). Countless preparatory drawings were made, some tentative and exploratory, in which the artist tried out different possible treatments of the figures – Andromache was always intended to stand in isolation at the centre of the composition but the eventual poses of the mass of the figures emerged more slowly. Once the overall choreography had been arranged into a fixed design (see plate 79) Leighton commenced the process of setting models for each of the figures, and working out their exact stances and interrelationships, as always studying the figures first in the nude and then with draperies.

Dorothy Dene provided the model for Andromache, and her sister Lena may be recognized as the young girl accompanied by children to the left of the figure of Andromache. Poses and gestures which Leighton had explored in earlier paintings were adapted – for example the red-haired girl for which Lena Dene modelled was a re-working in reverse of the pose she had assumed for *Gulnihal*.

Captive Andromache was acclaimed by Leighton's admirers, but with reservations. The *Magazine of Art* considered it the artist's *magnum opus*, and said of it: 'It has been thoroughly well thought out, and is not only an admirable example of the excellences and faults of its painter (whose pictorial shortcomings, curiously enough, are a thousand times more obvious than his many and subtle merits), but is in itself a complete exposition of the art of painting . . . subject, composition, line, character, colour – all are here, save that quality of atmosphere and tone to which a powerful section of the modern school of painting are devoting their almost exclusive attention, but which Sir Frederick has ignored with all but complete consistency.' The *Athenaeum*, which had long supported Leighton's cause, was also beginning to suggest that his most ambitious paintings

were too remote to be relevant or interesting to the public at large; according to F. G. Stephens, 'it is no disparagement to say that, as a whole, this work reminds us less of actual life than of an elaborate Greek bas-relief designed . . . in the spirit of the chorus of a grand drama . . .' More critical reviews were published in the *Times*, and the *Universal Review* found in the work the defect 'of knowledge trying in vain to do duty for spontaneity and life, of grace of deportment . . . being substituted for feeling and action. . . . The painter has not *seen* this subject, but concocted it – deliberation, not impulse, has presided over its birth.' Gradually a consensus emerged, which held that *Captive Andromache*, although a stupendous achievement in formal and technical terms, was too impersonal and dispassionate to be rewarding as a work of art.

Leighton always believed that he was addressing a wide audience in his large-scale paintings; even if their didactic function is confused and their message to the public equivocal, there was no doubt in his mind that they would serve a beneficial purpose because he believed that their abstract beauty would edify and uplift. Fortunately from Leighton's point of view, his later career coincided with the establishment and building up of public collections of art in Britain and the Empire, and so there was a demand for impressive and imposing works of art. After protracted negotiation *Captive Andromache* was bought for Manchester City Art Gallery for six thousand pounds.

One of the most personal paintings of Leighton's late career is *Invocation* (plate 80). The subject, a girl dancer or singer seeking the inspiration of her muse, is related in its elements, if not its mood, to *Electra at the Tomb of Agamemnon* of twenty years before. Here, however, all mythological association has been dispensed with, and the histrionic quality replaced by one of submission.

The translucent textures of the drapery are beautifully rendered. This is the type of painting of which Leighton said: 'I can paint a figure in three days, but it may take me thirty to drape it.' The girl is seen raising a diaphanous veil so that she may look directly at the goddess, her strongly built arms in dark silhouette against the white of her garment. The space she inhabits is defined by the diagonal line of the eaves of the temple building, and the vertical line of the fluted column. The figure is abruptly cut off by the bottom edge of the composition in a way which emphasizes her apparent physical closeness to the spectator. The impact of *Invocation* is abstract and symbolical; its force due to the physically impressive figure of the girl and the psychological intensity of her fixed expression.

One of the last paintings in which Leighton attempted to give a dynamic effect of movement was *Greek Girls playing at Ball* (plate 81), which, with *Invocation*, was exhibited at the Royal Academy in 1889. On the right a statuesque female figure recoils from the effort of throwing a ball; while on the left a second figure stretches to catch it. Leighton has sought to express the physical actions of each by the different treatment of the draperies. The thrower's recovery of her balance is echoed by the movement of a piece of material which streels out and winds around her, jerked momentarily into a fantastic serpentine shape; while the catcher seems to stream upwards within a chrysalis of comet-shaped draperies. Leighton perhaps had Ruskin in mind when he devised this extravagant arrangement; in *The Seven Lamps of Architecture* Ruskin had determined that the representation of drapery was ignoble and indulgent unless it served as a means of expressing motion or gravitation. Leighton himself considered the dynamic potential of draperies in a note in a sketch-book: 'Combination of expressed motion and rest source of fascination in drapery – wayward flow & ripple like living water together with absolute repose.' He may also have remembered Titian's *Rape of Europa* (Boston,

80. *Invocation*. Exhibited 1889. Oil on canvas, 55 × 33 in. (139.7 × 83.8 cm.). Private collection

81. *Greek Girls playing at Ball.* Exhibited 1889. Oil on canvas, 47 × 78 in. (119.4 × 198.1 cm.).
Kilmarnock and Loudoun District Museums, Dick Institute

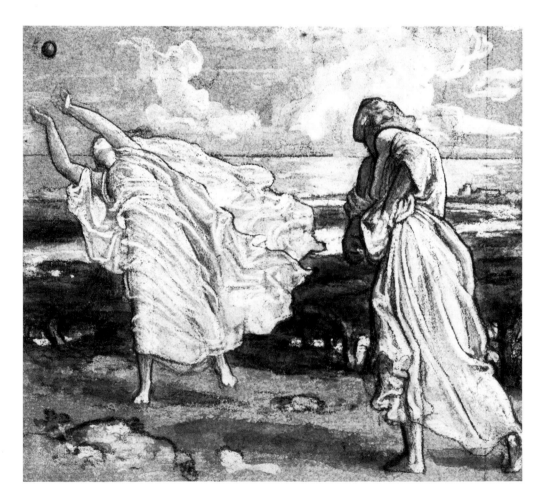

82. Compositional drawing for *Greek Girls playing at Ball.*
Pencil and white bodycolour on blue paper, 5 × 5¹/₂ in. (13 × 14.2 cm.). Private collection

Figure 3. *Sir Frederic Leighton in his studio, c.* 1890. Photograph.
National Portrait Gallery, London

Gardner Museum), which he had studied on the occasion of his visits to Stourhead in Wiltshire in the 1860s. In both paintings the draperies make extravagant patterns against a panoramic background.

Leighton explored the idea for *Greek Girls playing at Ball* in a chalk and body-colour drawing (plate 82). The figures as first conceived are more tightly compressed in relation to the overall format. The pronouncedly diagonal dynamic of the composition made for a pictorially exciting and vigorous impact, which was essentially baroque in character. However, in the course of the gestation of the painting Leighton allowed the figures to drift apart, perhaps so as to be able to insert between them another of the Mediterranean-inspired panoramic views of which he was so fond. As a result the painting loses some of the power of the drawing, and becomes more blandly classical in its systematic horizontal divisions and in the arrangement of the figures into balanced but separate flanking compartments.

The last painting which Leighton made of the female nude for its own sake, *The Bath of Psyche* (plate 86), was one of his most serene and visually satisfying images. The moment represented is that where Psyche undresses and prepares to bathe in readiness for her bridegroom Cupid.

When establishing the pose of the model, with arms raised and body emerging from the draperies which hang from her shoulders, Leighton perhaps had in mind the famous *Callipygian Venus*, in which a young girl pulls aside her dress to expose her legs and buttocks. The arrangement is subtle and refined. The girl is standing at the extreme edge of the pool of water, in which the reflection of her legs and feet appears. Beyond is a

flight of four marble stairs, from which rise two fluted columns, their golden capitals and the roof which they support seen at the top edge of the painting. The space between the two columns is closed by a purple curtain, above which is glimpsed a vividly coloured evening sky. The integrity of the architectonic setting provides a foil to the soft flesh of Psyche and the lightness of her falling draperies. The pronounced verticality seems to emphasize her slenderness; while the Ionic order of the framing columns echoes her femininity and elegance.

The naked figure is exposed for the delectation of her unseen admirers, just as in the legend the person of Psyche was offered to an unknown husband. The undoubted sensuality of the painting was recognized by Leighton's contemporaries; according to J. Harlaw: 'Psyche's contour is perfect and her form is deliciously rounded. The exquisite pearly fairness of the skin must ever make this rendering of the amorous deity the standard of colour as of modelling . . . Dorothy Dene, Leighton's favourite model, here displays her charms for the admiration of mankind.' *The Bath of Psyche* was perhaps close to the boundary of what was permissible in terms of the display of the female nude. Leighton largely escaped the charge of lewdness, which was levelled against his contemporaries Alma-Tadema and Poynter for example, partly because his nude subjects illustrated mythological events which were acknowledged to require the treatment of nude figures, and partly because they were sufficiently generalized to fulfil that central criterion of classicism which rejected the specific or the recognizable. Thus Leighton's paintings were generally accepted as being elevating and morally instructive, whereas Tadema's were considered brilliant in execution but salacious in purpose. Leighton believed that the representation of the nude was the ultimate object of classical art and the expression of a type of beauty more uplifting than any other; he refused to countenance the views of those who believed that nude subjects should be withheld from public display.

The summer exhibition of 1891 included two of Leighton's most remarkable late mythological subjects, *Perseus and Andromeda* and *The Return of Persephone*. Whereas most of Leighton's classical paintings of his middle career had been of subjects only tangentially related to the canon of ancient myth, in his later work he was prepared to address the central events of ancient literature.

Perseus and Andromeda (plate 83) is based on Ovid's story from the *Metamorphoses*. Andromeda, nude except for a drapery at her waist, is bound to a rocky promontory and in the clutch of the beast. Perseus, mounted on his winged steed Pegasus, appears in the sky above. The setting is a sinister coastline, where vertiginous rock cliffs rise from oily waters. The symbolism is expressed in the rich and contrasting colours of the protagonists: the gold and white of the heroic Perseus; and the green and black of the evil monster; as well as the soft pink of Andromeda's flesh, the icy white of her draperies, and the golden red of her hair.

It is interesting to consider how Leighton achieved the realistic and three-dimensional quality of this painting. The pose of the girl could be observed in whatever position or from whatever angle the composition required by setting a model in the studio; the mythic dragon was invented on the basis of studies made of models and prehistoric animals; the rocky coastline and fiord were based on sketches done on the west coast of Ireland. Leighton's difficulty came with the mounted figure of Perseus, and here he resorted to plagiarizing the work of another artist – this group was studied from a model (plate 84) which Leighton constructed on the basis of a print by the Dutch engraver Hendrik Goltzius. This is the weakest and least convincing part of the finished painting.

The legend of Perseus and Andromeda provided the theme of a later painting by Leighton, *Perseus on Pegasus hastening to the Rescue of Andromeda* (plate 85), which was left, perhaps unfinished, in the artist's

83. *Perseus and Andromeda*. Exhibited 1891. Oil on canvas, $92^1/_2 \times 50^7/_8$ in. (235 × 129.3 cm.).
National Museums and Galleries on Merseyside (Walker Art Gallery, Liverpool)

84. Model for *Perseus and Andromeda*. Bronze, height including base: 30³/₄ in. (78.1 cm.).
The Royal Academy of Arts, London

studio at his death. The same model of the mounted figure of Perseus has been used for the central group, on this occasion turned around and seen at closer range. Leighton's two paintings of Perseus are distinguished by the differences in their dynamic balance. The first, *Perseus and Andromeda*, is full of action and leads the eye into distance; while the second, *Perseus on Pegasus*, is classically balanced and contained within a narrow picture plane. The two represent opposite pictorial approaches: on the one hand story-telling by dramatic compositional means; on the other the decorative but essentially uninformative arrangement of pictorial elements.

The legend of Persephone also comes from the *Metamorphoses* and was frequently represented both in ancient art, painted on vases or carved in reliefs, and by European painters of the Renaissance and Baroque periods. Leighton's painting (plate 87) shows the limp corpse of Persephone, wearing a shroud-like drapery over her yellow undergarment, being carried upwards by Hermes, the messenger of the gods. Persephone is awaited by her mother Demeter, dressed in a warm-coloured and voluminous drapery, whose strong, sun-browned arms are stretched wide to embrace her beloved daughter. The scene of reunion is set at the mouth of

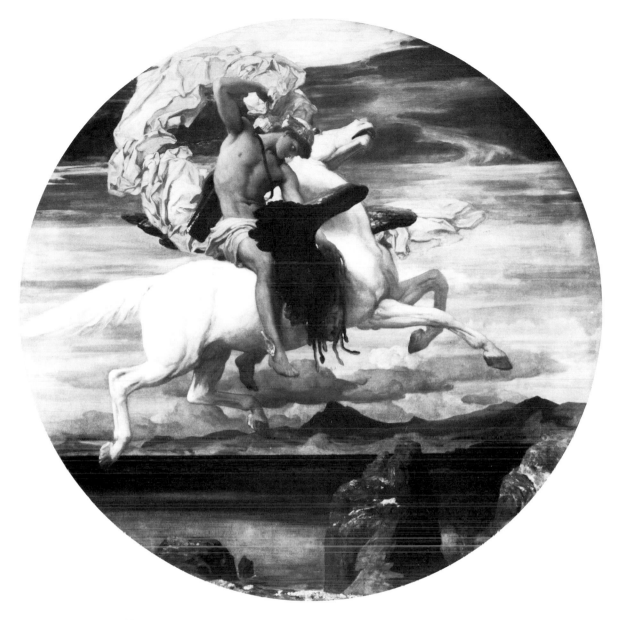

85. *Perseus on Pegasus hastening to the Rescue of Andromeda. c.*1895–6.
Oil on canvas, diameter: 72^1/$_2$ in. (184.2 cm.). Leicestershire Museum and Art Gallery, Leicester

the cave which leads into the Underworld: below is darkness and death; while above is a cloud-strewn sky and the bright light of day. The transition is represented by the contrast between the few heliophobic plants which survive around the inside of the mouth of the cave and the spray of cherry-blossom seen beyond. The fertile landscape burgeons as a consequence of Persephone having regained the light of the sun.

In the last years of Leighton's life the adoption of mythological subjects in which the sun is represented as the essential energizing force became for the painter akin to an act of faith. He was particularly attracted to the figure of Clytie, and painted two works which illustrate her legend. Ovid described in the *Metamorphoses* how Clytie had been loved and then spurned by Apollo the god of the sun. She was devastated by the loss of his love, and for nine days she remained with her eyes fixed upon him. Finally she was changed into a heliotrope so that she might turn her face to the sun for ever.

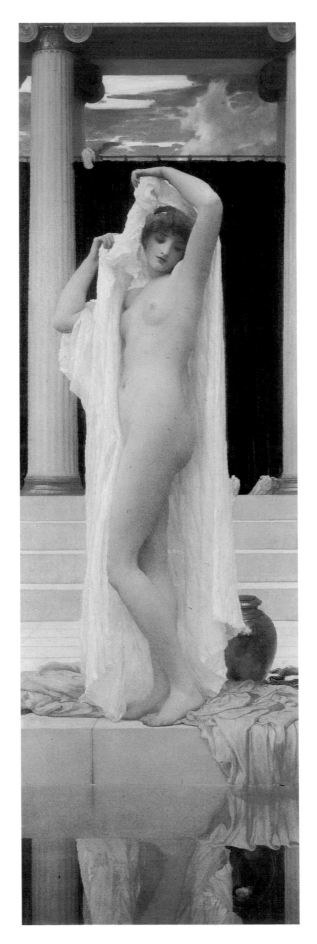

86. *The Bath of Psyche*. Exhibited 1890. Oil on canvas, $74^1/_2 \times 24^1/_2$ in. $(189.2 \times 62.2$ cm.$)$. Tate Gallery, London

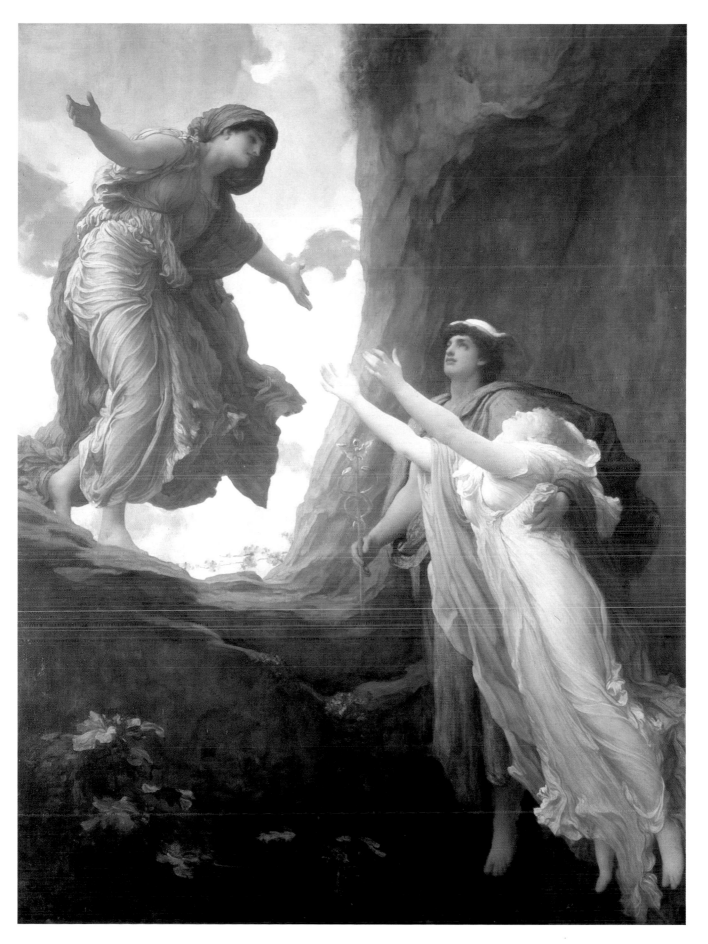

87. *The Return of Persephone*. Exhibited 1891. Oil on canvas, 80 × 60 in. (203.2 × 152.4 cm.). Leeds City Art Gallery

88. Drawn study for *Clytie*. Black and white chalks on brown paper, $7^1/_4 \times 6^3/_8$ in. (18.4×16.2 cm.).
British Museum, London

The first of Leighton's paintings of Clytie (plate 90) shows a wide landscape, probably seen at dawn rather than sunset, the land largely masked in shadow by the clouds lit with radiant sunlight. At the right-hand side is the diminutive figure of Clytie, kneeling and with outstretched arms, joyfully welcoming her erstwhile lover as the sun reappears at the eastern horizon. Beside her is an altar and, standing on the top of a column, a statue of Apollo. Leighton's second version of the subject (private collection), which remained unfinished in his studio at his death, shows Clytie as the central motif of the composition (for a drawn study, see plate 88).

Throughout his career Leighton introduced landscape elements into his figurative paintings, usually as a carefully calculated caesura within an architectonic scheme. The first version of *Clytie* stands alone among his works as a naturalistic landscape painting in which the mythological element is incidental. *Clytie* was praised when it was exhibited at the Royal Academy in 1892 and Leighton himself attached importance to it, writing: 'I myself have a weakness for this picture which I brewed for some 15 years.'

A more important work, indeed a painting which more than any other has come to be seen as representing the essential characteristics of Leighton's mature art, is *The Garden of the Hesperides* (plate 91). Here again the sun, and the mythic personifications associated with it, are central to the iconography.

The painting provides a vision of a world of abundance and tranquillity. The Hesperides, the daughters of evening who lived in a sacred garden in the far west, are represented as three languid women, made torpid by the sound of their own music and the warmth of the sun. Dressed in gorgeous draperies of red, gold and greeny-bronze, they lie back against the trunk of a tree, and around their limbs, and up into the bole of the tree, wind the coils of a stupendous snake, the dragon Ladon. The golden fruit which it is their duty to guard hangs down in heavy bunches, and all around is luxuriant vegetation. Beyond is the ocean, inky black and glittering with the reflected light of the sun.

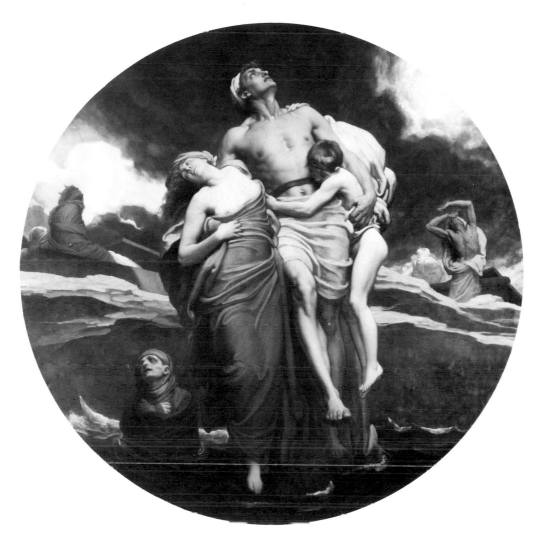

89. *'And the sea gave up the dead which were in it'*. Exhibited 1892.
Oil on canvas, diameter: 90 in. (228.6 cm.). Tate Gallery, London

Leighton would certainly have known Milton's poem *Comus*, the concluding lines of which describe 'the gardens fair/ Of Hespurus, and his daughters three/ That sing about the golden tree'. Another likely source was Alfred Tennyson's early poem *The Hesperides*. The moral implications of the mythical theme had been considered in detail by Ruskin in his discussion of a painting by Turner, in Volume V of *Modern Painters*. Something of the decadent flavour of Gustave Flaubert's notorious novel *Salammbô*, where on one occasion a woman is made love to by a snake, is sensed in Leighton's great painting.

The composition, which is based upon a balance of conflicting dynamics, was a revision of one which Leighton had first devised in 1868 for *Acme and Septimius*, also a tondo. It depends upon the superimposition of a triangular mass of bodies and draperies on a background loosely divided according to a system of radiating lines. The circularity is symbolic of the unchanging character of the world the Hesperides inhabit and the perpetual cycle of their duty; the crossed lines of the background tell of unseen hazards and the lesson that nothing resists the passage of time.

On rare occasions in his late career Leighton turned to Biblical subjects. *'And the sea gave up the dead which were in it'* (plate 89) represents Leighton's vision of the resurrection of souls on the Day of Judgement.

129

90. *Clytie.* Exhibited 1892. Oil on canvas, $33\frac{1}{2} \times 54\frac{1}{4}$ in. (85.1×137.8 cm.).
Fitzwilliam Museum, Cambridge (on loan to Leighton House)

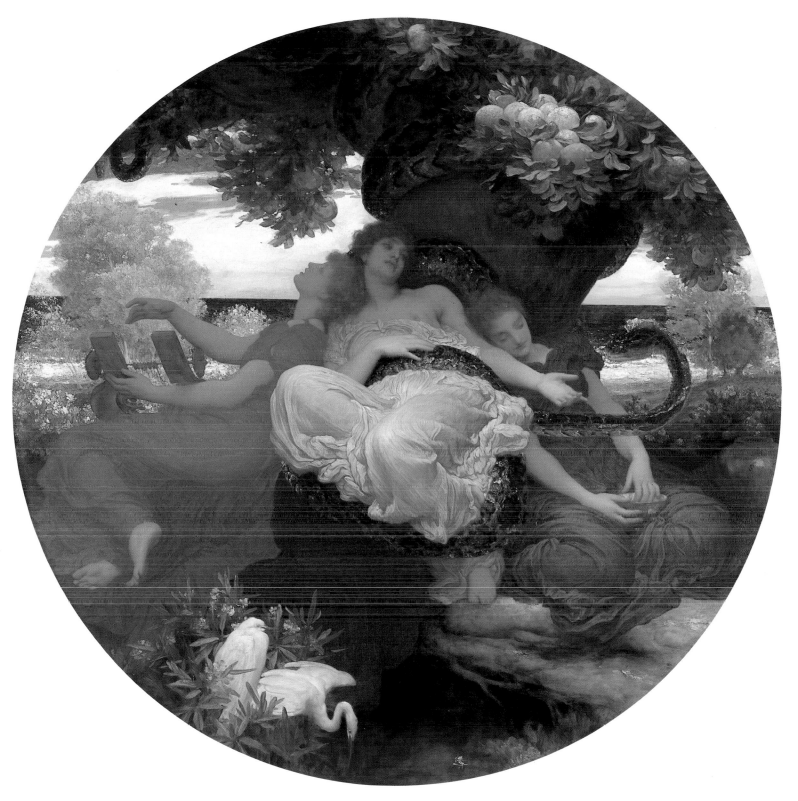

91. *The Garden of the Hesperides*. Exhibited 1892. Oil on canvas, diameter: 66¹/₂ in. (169 cm.).
National Museums and Galleries on Merseyside (Lady Lever Art Gallery, Port Sunlight)

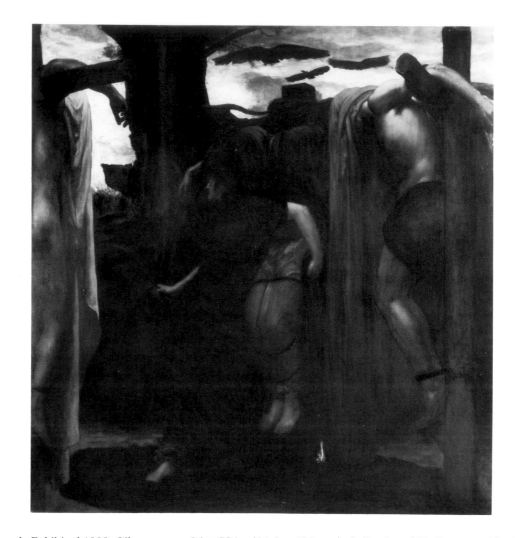

92. *Rizpah*. Exhibited 1893. Oil on canvas, 36 × 52 in. (91.5 × 132 cm.). Collection of Sir George and Lady Christie

With *Rizpah* (plate 92) he returned to the Old Testament, the stories of which had fascinated him in the 1860s and 1870s, and specifically to an episode connected with King David in Chapter 21 of the Second Book of Samuel.

This painting was seen as an aberrant production on Leighton's part. As F. G. Stephens recognized: 'The President was in a more sombre mood than usual while he designed *Rizpah*. She is grouped here with her ghastly companions in a sort of close circle. Gaunt, wan, yet inspired by indomitable resolution, she clutches a sickle for a weapon against the birds of prey which infest the place of death. The design is full of passion and terror, such as rarely accompany a mode of execution so highly cultured, not to say academic, as Sir Frederic Leighton's, who betrays a somewhat marked preference for an unusually smooth surface and an almost monumental uniformity of texture.' The grimness of Leighton's last Biblical subject, achieved by compositional and colouristic methods, as well as by the naturalistic treatment of the crucified corpses, is a reminder that Leighton was capable of creating horrific images.

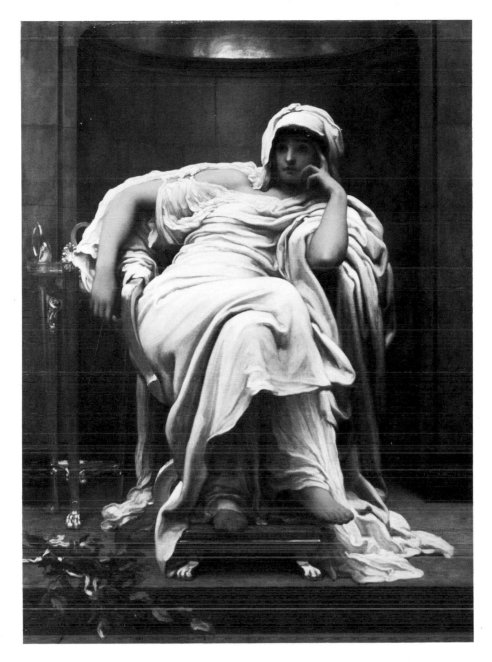

93. *Fatidica.* Exhibited 1894. Oil on canvas, 60 × 42⁷/₈ in. (152.5 × 109 cm.).
National Museums and Galleries on Merseyside (Lady Lever Art Gallery, Port Sunlight)

In the last years of his life Leighton reverted to the type of full-length figures of women, seated or stand-
ing, large in scale, and for the most part playing out roles which permit the abstract exploration of emotional
states. Whereas in his mythological subjects, such as *Perseus and Andromeda* and *The Bath of Psyche*,
Leighton had frequently represented woman as the victim of man, or as dependent upon his mercy, in these
late paintings she exists as an independent and isolated being, and she seems proudly indifferent to her fate.

Fatidica (plate 93) was shown at the summer exhibition in 1894, along with four other personifications
of women, ranging from a scene of domestic happiness entitled *The Bracelet* (The Fine Art Society, London) to
a work of patent symbolism, *The Spirit of the Summit* (Auckland City Art Gallery). Fatidica was a prophetess

94. *Flaming June.* Exhibited 1895. Oil on canvas, 47¹/₂ in. (120.6 cm.) square.
Museo de Arte de Ponce (The Luis A. Ferré Foundation), Puerto Rico

95. *Lachrymae*. Exhibited 1895. Oil on canvas, 62 × 24³/₄ in. (157.5 × 63 cm.).
Metropolitan Museum of Art, New York (Wolfe Fund, 1896, Catherine Lorillard Wolfe Collection)

who foretold the future to women; Leighton has represented her leaning back with her legs crossed, her head supported by her left hand and her right arm thrown back over the chair in which she sits. Her posture conveys a feeling of complete lassitude, and her facial expression as she gazes enigmatically into the distance is utterly impassive. The pose is derived in a general sense from the seated prophets and sibyls of Michelangelo's Sistine Chapel ceiling.

Leighton dressed his model in loose-fitting drapery which falls in heavy, sculptural folds; the woman's body seems to be slumped under their weight. The paint is handled with expressive thickness, and the colour is harmoniously muted to support the mood of the subject: the draperies are the dull white of plaster tinged with dirty green, and as they are lit from in front there is none of that quality of translucence which Leighton had so often delighted to convey. The masonry of the background is purple grey. Touches of brighter colour are provided in the spray of laurel leaves at her feet, and the overall dullness of surface is relieved by flecks of reflected light in the metal tripod at Fatidica's right hand, and in the gilded ceiling of the niche.

During the last decades of the nineteenth century an attitude of mind emerged which held that an artist should strive to instil an abstract quality of beauty into his works. Art was not required to stem from or reflect the way in which the mass of people lived, nor was it seen as a means of inculcating moral truths or improving the population, except in the sense that beauty was in itself uplifting. Art was its own master and served its own purpose. Artists sought to express emotions which told of man's aspirations and desires and of the miseries of human existence, as reflected not in life itself but in the literature and mythology of the ancient world.

Lachrymae (plate 95) does not depend upon a mythological or historical event, but is rather the product of the artist's own contemplation of how a theme of grief or loss might be expressed in the representation of a mourning figure. The painter has conveyed a tragic intensity of feeling by the concerted means of colour and composition. The arrangement of forms is pronouncedly upright: the figure of a woman, dressed in black robes which brush the marble pavement, leans against a fluted Doric column, resting her right arm on the flat top and sinking her head on her shoulder. Above her rises the trunk of a yew tree, an element which lends emphasis to her impressive height. In the background is seen a glittering pattern of light, suggestive of a funeral pyre.

The prevailing verticality is symbolic of the ascending spirit of the departed lover; the woman seems to yearn to follow, but cannot, and thus she hangs her head. A cross is described by the junction of the wall and the column; and just as circularity may be recognized as the symbol of continuity and peacefulness, this pattern of conflicting shapes signifies the end or interruption of happiness.

Standing with *Lachrymae* in the artist's studio in preparation for the Royal Academy summer exhibition of 1895 – the last that Leighton was to see – was *Flaming June* (plate 94). This painting has no ostensible subject but simply represents a beautiful young woman sleeping on a stone bench in the brilliant light of a summer afternoon. Traditionally in European art the representation of sleeping figures has lent itself to erotic associations; where sleeping girls are seen in paintings it is often assumed that their dreams are of love.

The pose of the figure is extraordinary. Staley quoted Leighton as saying: 'The design was not a deliberate one, but was suggested by a chance attitude of a weary model who had a particularly supple figure'. Similarly, Leighton's sculpture *The Sluggard* was reputed to have represented the gesture of a model unaware of the artist. An alternative theory is that the figure was suggested by Michelangelo's *Night* in the Medici Chapel in Florence. This and other of Leighton's late figurative compositions are Michelangelesque in the sense that the massive and strongly three-dimensional form gives a feeling of compressed energy which seems to want to

96. Compositional drawing for *Flaming June*. Black and white chalks on brown paper, $3^{13}/_{16} \times 3^5/_8$ in. (9.6 × 9.1 cm.).
Museo de Arte de Ponce (The Luis A. Ferré Foundation), Puerto Rico

burst free from the constraining configuration of the limbs. The most immediate and obvious source for the posture of the slumped and sleeping figure of *Flaming June* was Watts's painting *Hope*, the first version of which had been exhibited at the Grosvenor Gallery in 1886. Leighton had used this figure type before, once for one of the women in *Captive Andromache*, and then again in the architectural ornament of *Summer Slumber*.

The finished painting is the product of long contemplation of the model. Many drawings were made in which Leighton experimented with and refined the idea for the painting, constantly working towards a more flowing and rhythmic distribution, and a more compressed and commensurately dynamic composition. Subsidiary details – the mountainous islands in the background for example – are pared down as the enclosing boundary line which was to represent the eventual confine of the picture space cuts closer to the figure itself. The compositional studies are done with a frenzied urgency and roughness of texture (see plate 96). The final arrangement is a brilliant exercise in foreshortening: the woman curls sideways on the bench; her waist and chest are concealed while her right thigh is massively emphasized; her left knee is drawn up; her head lies in a cradle formed by her arms. Her body is compressed into a position where each limb supports another and in which drapery flows over the compacted form like molten lava. The effect is immensely rich; the rhythm of the S-shaped form, and the volumetric quality conveyed by the mass of the figure, compel attention.

Even more astonishing than the composition is the impact of the colour. The dress which the sleeping woman wears, although gauze-like and transparent in texture, is painted in the most brilliant orange tones, and strikes the eye like a living flame. Areas of her face and neck, forearms and foot, assume a glowing tone which is transmitted from the tint of her garment. A further drapery, of a muted brown, hangs over her head

137

97. *Still-life Study of Fruit on a Marble Sarcophagus.* 1895.
Oil on canvas, $4^7/_8 \times 5$ in. (12.4 × 12.7 cm.). Victoria and Albert Museum, London

and cascades downwards on either side of her. Above the marble parapet, from which curious Ionic volutes project, a spray of oleander appears, with lustrous leaves and delicate flowers, the carmine pink of which clashes with the prevailing orange. Beyond, the sea is glimpsed, deep blue to right and left, and white and gold with the sun's reflections ahead. Every colour is seen as if through a gauze which lends a unifying tone of shadowed brilliance; and a feeling of heat is expressed by the way in which the surfaces seem to melt into one another. *Flaming June* celebrates the continuity and regeneration of youthful beauty, and in this work the sad undertone of the music of time is not heard.

Leighton's life was drawing to its close. Although his health began to fail – during the last couple of years he suffered a series of atacks of angina – he painted as well as ever, and took up a number of ambitious new subjects, some of which were left unfinished at his death. For many years he had spent the late summer and autumn in the South, staying in Perugia to write his biennial Academy Addresses and visiting favourite haunts and old friends, and always looking at paintings in galleries and churches. He made his last journey to Italy in the autumn of 1895, on which occasion he was well enough to make oil studies out of doors. A small but delicious painting of fruit on a stone sarcophagus (plate 97), a preparatory study for a detail in Leighton's last painting of Clytie, was reported by Costa to have given him the satisfaction which he had long derived from meditating on the appearance of natural forms.

On 25 January 1896 Leighton died at his house in Holland Park Road. His funeral in St Paul's Cathedral was the occasion of an expression of public grief at the passing of the most distinguished nineteenth-century President of the Royal Academy and the most eminent painter of the Victorian age.

Conclusion

Leighton loomed large among his contemporaries and was more prominent in public life than any other painter whose career fell within the span of the reign of Queen Victoria. If we can establish his stature as an artist we will have succeeded in demonstrating the importance and value of Victorian art *per se*.

Victorian classicism, of which movement Leighton was the leading exponent among painters, fulfils some but not all of the requirements which historians place upon such phases of artistic revival. Leighton admired and assimilated ancient art wherever he had the opportunity to do so. But true classicism depends upon more than the mere adoption of the supposed guise of the ancient world and a penchant for classically posed nude or draped figures. The virtue of a classical style of art is its directness and accessibility; works which have a genuine claim to be considered as products of the classical tradition make their impact by economy of narrative and absence of formal elaboration. As Ives Gamell wrote in *The Twilight of Painting* (1945), 'First-rate academic art always conveys a sense of the high import of its subject matter The painter whose imagination is really stirred by a subject of this type will seek to paint it in such a way that the spectator will be gripped by its tragic intensity, its solemn grandeur, or its symbolic implications.' Art which depends upon the reconstruction of the ancient world but which fails to address the aesthetic implications of its power to influence and inform an audience, is at best a revival of classical form rather than a renaissance, at worst mere decorator's pastiche.

Leighton was capable of both extremes: certain of his early paintings are sufficiently forthright to make their subjects powerful and impressive, and equally, various of his later works compel the attention of the spectator by their timeless treatment of human predicaments. One of the discoveries of the English Aesthetic Movement, inspired as it was by the principle of 'art for art's sake', was that figurative subjects need not depend upon narrative to involve the spectator. Some of Leighton's most significant works are of this type: single figures whose state of mind may be understood, or groups in which scenes of confrontation or quiet communication are represented. These works satisfy that fundamental criterion of classicism that the spectator should respond emotionally to the action or mood of the piece.

There is, however, another category of work, where the absence of any unfolding subject or the deliberate avoidance of a stirring or significant moment in a given narrative causes the spectator to depend for his enjoyment on purely decorative qualities. As Richard Ormond has written: 'The classical tradition only continued to be viable in so far as it was able to adapt to new modes of thought and feeling. Beauty and poetic suggestiveness had replaced the idea of truth, knowledge and right action, characteristic of an earlier generation of neoclassicists. If Leighton looked back to classical prototypes, he did so through the eyes of a Victorian aesthete, whose primary concern was to please the eye and elevate the imagination of his audience, not to belabour them with the perfection of Greek form.' Leighton occasionally painted subjects which are rich in their forms and

arrangements and yet uninspiring to look at because the spectator's emotions are not addressed. These works seem anaemic and remote when considered in terms of an historical tradition of classical art.

In the twentieth century the sometimes grandiose classical paintings of nineteenth-century artists are often viewed with mistrust; we reserve our terms of ultimate praise for forms of art which are impassioned and spontaneous expressions of the artist's direct experience of the world. Leighton's urge to achieve ever higher standards of technical refinement, more immaculately finished textures and harmoniously and subtly arranged compositions, and his commensurate dependence on the elaborate and drawn-out processes by which so-called academic works are constructed, lead a modern audience to doubt the authenticity of his inspiration and the intensity of his feeling.

Curiously, there is an aspect to Leighton's art which speaks more directly to modern sensibilities. His preparatory oil sketches and his studies of natural detail and landscape have the economy of means and intuitive directness which we particularly admire in the art of his contemporaries the Impressionists. Nevertheless, this highly personal type of work, which served the purpose of recording his impressions of his surroundings and which was essentially a means of working out problems of pictorial representation, is only one aspect of his artistic mentality. The works which Leighton set before his contemporaries, and by which he himself expected to be judged, are those upon which his significance as an artist must eventually rest, even if they convey a less distinct sense of the artist's personality.

It must be accepted that much of Leighton's art reflects his fundamental reserve. He was not a man who felt the need to communicate his inner feelings or his experience of life through the medium of art; nor was he an artist capable of moving an audience emotionally. By comparison with some of his more forthcoming contemporaries, most notably Edward Burne-Jones, he seems cold and unfeeling. None the less, it is the case that Leighton cared passionately about the purpose which his art served — which was that it should uplift and inspire by the function of an abstract beauty intrinsic in the harmonious arrangement of colour and line.

The formal qualities of his art were essentially more important and powerful than its capacity to inform an audience. His strength lay in his extraordinary visual sense and in his capacity to compose in a way which was both decorative and symbolically informative; he knew how to arrange colour and texture with sumptuous effect; and he represented the external world with a degree of naturalism which pleases the eye without falling into the trap of mere duplication of reality. Leighton's art, which might at first seem dry and dependent upon erudite interpretation, is in fact sensuous and even passionate. His paintings testify to his long contemplation of how the paint itself may be used to convey the qualities of textures and light. It is on this level, where one can appreciate the excitement and bravura with which he handled his materials, that his works may be most completely enjoyed.

Chronology

1830 31 December – born at 13 Brunswick Terrace, Scarborough, Yorkshire. Second child of Frederic Septimus Leighton and Augusta Susan Nash.

1839 Leighton family visit Paris.

1840 Leighton family in Rome, 1840–1. Attends University College School in London.

1841 Leighton family travel to Germany, Switzerland and Italy.

1842 Enrols at the Academy of Art in Berlin.

1843 Attends school in Frankfurt.

1845 Leighton family move to Florence. Enrols at the Accademia di Belle Arti, Florence.

1846 Dr Leighton buys a house in Frankfurt. Studies at the Städelsches Kunstinstitut in Frankfurt.

1848 Political upheavals force the Leighton family to move to Brussels. Makes contact with the painters Wiertz and Gallait. Moves to Paris.

1849 Attends the *atelier* of Alexandre Dupuis.

1850 Exhibits *Cimabue finding Giotto in the Fields of Florence* in Frankfurt. Returns to Frankfurt from Paris, re-enrols at the Städelsches Institut. First contact with Edward von Steinle, professor of history painting at the Städelsches Kunstinstitut. Friendship with Enrico Gamba.

1851 Visits London to paint a portrait of his great-uncle. Makes contact with various English artists, including Alfred Elmore. Visits the Great Exhibition.

1852 Family home established in Bath. Travels with Gamba through the Austrian Tyrol and northern Italy, visiting Verona, Venice and Florence, to Rome. Takes a studio in the Via della Purificazione.

1853 First meeting with Giovanni Costa and George Heming Mason. Friendship with Adelaide Sartoris. Other friends include George Aitchison, William Burges and Alfred Waterhouse.

1854 Takes a studio in the Via Felice, Rome. Works on *Cimabue's Madonna* and *The Reconciliation of the Montagues and Capulets*. Contact with Adolphe-William Bouguereau. Through Mrs Sartoris meets Robert Browning, with whom he was to enjoy an enduring friendship.

1855 Exhibits *Cimabue's Madonna* at the Royal Academy; the painting is purchased by Queen Victoria. Exhibits *The Reconciliation of the Montagues and Capulets* in Paris. Takes a studio in the rue Pigalle, Paris. Meets the painters Decamps, Robert Henry, Ricard and Ary Scheffer; also Ingres.

1858 Returns to London. Makes contact with the Pre-Raphaelites.

1859 Takes a studio at 2 Orme Square, London.

1860 First work as an illustrator.

1861 Death of Elizabeth Barrett Browning. Designs her tomb in the Protestant Cemetery in Florence.

1862 Begins work on the mural *The Wise and Foolish Virgins* for St Michael's, Lyndhurst.

1864 Elected an Associate of the Royal Academy. Commissions George Aitchison to build him a house in Holland Park Road.

1866 Visits Spain. Moves into his new house.

1867 Travels to Asia Minor and Greece.

1868 Elected a full Member of the Royal Academy.

1869 Serves on the hanging committee of the Royal Academy Summer Exhibition. Among his own exhibits is his Diploma Piece, *St Jerome*. Involved in the organization of the Royal Academy Winter Exhibitions, the first of which takes place in 1870.

1877 First Grosvenor Gallery exhibition.
 Commences the building of the Arab Hall at his house in Holland Park Road.

1878 Elected President of the Royal Academy; Knighted.

1879 Death of Adelaide Sartoris. First uses Dorothy Dene as a model. Gives his first Academy Address.

1885 Created a Baronet.

1894 Works on his mural *Phoenicians bartering with Ancient Britons* for the Royal Exchange building.

1895 Travels to North Africa. Last journey to Italy; visits Venice, Naples and Rome.

1896 Created Baron Leighton of Stretton in the New Year Honours List.
 25 January – dies at his house in London.
 3 February – Funeral at St Paul's Cathedral.

1897 Memorial exhibition at the Royal Academy.

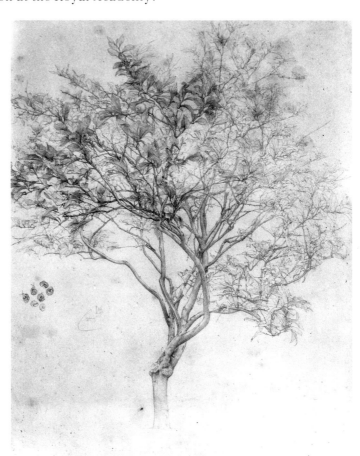

98. *A Study of a Lemon Tree*. 1859. Silverpoint on white paper, 21 × 15½ in. (53.4 × 39.4 cm.). Private collection

Select Bibliography

Mrs A. Lang, *Sir Frederick Leighton*, London, 1884.

Ernest Rhys, with a prefatory essay by Frederic George Stephens, *Sir Frederic Leighton Bart., P.R.A. An Illustrated Chronicle*, London, 1895.

Sir William Blake Richmond. 'Lord Leighton and his Art (A Tribute)'; obituary in *The Nineteenth Century*, London, March 1896.

Addresses Delivered to the Students of the Royal Academy by the Late Lord Leighton, London, 1896.

Remaining Works and the Collection of Ancient and Modern Pictures and Water-colour drawings of Lord Leighton; catalogue of Christie's sale in London, 11 and 13 July 1896.

Exhibition of Works by the Late Lord Leighton of Stretton, P.R.A., The Royal Academy, London, 1897.

Giovanni Costa, 'Notes on Lord Leighton', in *The Cornhill Magazine*, Vol. II, N.S., London, 1897, p. 373.

Drawings and Studies by the late Lord Leighton of Stretton, P.R.A.; exhibition catalogue, Fine Art Society, London, 1898.

G. C. Williamson, *Frederic Lord Leighton*, London, 1902.

John Ruskin, 'Classic Schools of Painting – Sir F. Leighton and Alma Tadema', Cook and Wedderburn's Library edition of *The Works of Ruskin*, Vol. XXXIII, pp. 306–26, London, 1903–12.

Alice Corkran, *Frederic Leighton*, London, 1904.

Mrs Russell Barrington, *Life, Letters and Work of Frederic Leighton*; two vols, London, 1906.

John Edgcumbe Staley, *Lord Leighton of Stretton, P.R.A.*, London, 1906.

Alfred Lys Baldry, *Leighton*, London, 1908.

J. Harlaw, *The Charm of Leighton*, London, 1913.

Richard Ormond, *Leighton's Frescoes in the Victoria and Albert Museum*, London, 1975.

Leonée and Richard Ormond, *Lord Leighton*, London, 1975.

Victorian High Renaissance; exhibition catalogue, with contributions by Gregory Hedberg, Allen Staley, Leonée Ormond, Richard Ormond and Richard Dorment; Manchester, Minneapolis and Brooklyn, The Minneapolis Institute of Arts, 1978–9.

Index

144